No Man's Land

Ann Thomas

No Man's Land
The Photography of Lynne Cohen

With over 120 illustrations in duotone and color

Thames & Hudson

National Gallery Musée des beaux-arts
of Canada du Canada

© 2001 Thames & Hudson Ltd, London

All Lynne Cohen photographs © 2001 Lynne Cohen

First published in hardcover in the United States of America in 2001 by
Thames & Hudson Inc., 500 Fifth Avenue, New York, New York 10110

Library of Congress Catalog Card Number 2001086849
ISBN 0-500-54240-6

Printed and bound in Italy by EBS

Contents

Preface

Some years ago a curator who was a passionate advocate of Lynne Cohen's photography showed a selection of her prints to a New York publisher. The latter was by turns amused and perturbed by what he saw. 'Where does she find these bizarre places?', he asked. 'Have you had a look at your own lobby recently?', came the reply, '...the sixties motifs, the Formica masquerading as mahogany, that half-dead rubber plant in the corner?' Ruefully, the publisher admitted that the site would indeed have been a perfect candidate for Cohen's unblinking gaze.

The story underlines how the environments in which human beings live and work are strangely almost below the threshold of perception. We hardly register their existence until they are presented to us in the form of Cohen's photographs. Her pictures force us to confront them head on: only then do we assess the sites as funny, or disturbing, or disorienting, and frankly perplexing. Surely, we tell ourselves, these are installations mischievously concocted by Cohen as parodies of the real world.

Would it were so! On the contrary, they are serious, sometimes (as in the ominous military installations) deadly serious environments. Even in the more benign sites it is not difficult to detect their builders' yearning to mould human thoughts and desires and to subjugate all that is natural.

Cohen presents us with a chilling vision of the world, a humanly engineered environment where the boundaries between 'inside and outside', 'nature and culture' , 'pleasure and pain' have been blurred, and stripped of their original connotations. She shows us that germ warfare laboratories are not so different from health spas, that robot factories are remarkably similar to classrooms, men's clubs to women's hairdressing salons, ballrooms to mortuaries.

For almost three decades Lynne Cohen has been hunting down and photographing human interiors of an astonishing variety. So weird are many of these places – the art historian David Mellor refers to them as 'cheerfully grim' – that we wonder if Cohen isn't actually on a mission from another world, sent to record the unfathomable constructions of a strange species, like a nature photographer dispatched to an exotic land to bring back pictures of termite mounds and other animal wonders.

The viewer should not overlook the fact that part of Cohen's achievement is having managed to secure access to the places she photographs. Many of the sites are difficult to penetrate: suspicion reigns, sometimes for good reason. Cohen has said that the easiest places for her to get into are, ironically, military bases. The modern military base employs a public relations officer, who is eager to please and welcomes allcomers. By contrast, the most difficult places to access are psychology laboratories in universities. Here the people in charge are acutely sensitive to the 'delicate issues' relating to the use of their research, and all too inclined to see the camera as a potential troublemaker.

Cohen's work makes a significant contribution to the art of our time, in which vernacular architecture and imagery, household objects and synthetic materials (valiantly striving to be something they are not) play a crucial role in redefining the boundaries of art itself. The musician David Byrne once remarked that her extraordinary subjects make self-conscious contemporary art pale by comparison. 'These environments appear as a strange, exciting kind of art,' he wrote. 'It could be high-tech folk art. In fact, it seems that some of the best modern art exhibitions are going on out there in various institutions and building lobbies.'

Since 1976, when it first acquired some of her photographs, the National Gallery of Canada has been committed to Cohen's art. It joins the Musée de l'Elysée in Lausanne, Switzerland, whose Director has also had a long association with Cohen's work, in the preparation of this exhibition and publication. The two museums have collaborated closely on the project, and would like to express their gratitude to Lynne Cohen, who was involved in the project at every stage, and to Ann Thomas, who organized the exhibition and contributed a fine essay on Cohen's work for this book.

Pierre Théberge, C.Q.
Director
National Gallery of Canada
Ottawa

William A. Ewing
Director
Musée de l'Elysée
Lausanne

Appropriating the Everyday

Lynne Cohen's images offer a wry commentary on the rich and often contradictory relationship between the objects and activities of our contemporary world and the spaces in which they are accommodated. Cohen photographs a wide range of ordinary interiors – living rooms, resorts, showrooms, libraries, offices, hairdressing salons, classrooms, lobbies of apartment buildings, spas, laboratories... These are spaces to which, in the normal course of events, we pay little attention, unless the building or its furniture are the work of an outstanding architect or designer. But by isolating these areas and representing them in photographs, Cohen reconfigures familiar terrain in the form of a work of art, and in so doing makes that terrain unfamiliar, even alien.

Confronted by these images, viewers find it hard at first to acknowledge that Cohen's spaces are neither installations created by the artist herself nor areas remote from our daily environment. To be forced to concede not only their existence but also their ubiquitousness is to admit to having only a selective awareness of our surroundings. How else can we account for the fact that our initial reaction to these photographs of places that we encounter every day is one of disbelief? Presented in a direct and apparently unmediated manner, not unlike photographs of theatre or film sets, Cohen's photographs oblige us to reconsider the environments in which we live, work and play. Rich with potential narrative, they show classrooms camouflaged as bedrooms, observation rooms that look like playrooms, and spas that resemble laboratories. They remind us of the choices people make when they create these interiors. As obscure and irrational as the grounds for these choices sometimes seem, the furnishings, wall decorations, colours and spatial ordering have been created with intent. And the substance of Lynne Cohen's photographs is the interplay between this intent and its material expression.

Cohen's photographs, because of their strong formal presence, make an important contribution to twentieth-century art, the parameters of which have been redefined by the use in art of vernacular architecture and imagery, ordinary domestic objects and contemporary synthetic materials. Their precise isolation of the depicted spaces and their extraordinary clarity in presenting the details that make up the scene before the camera enable them to take the viewer into a deeper appreciation of the commonplace and its relationship to the art of our times.

The appearance of the commonplace changed dramatically in the early twentieth century with the introduction of plastic laminates, plywood, simulated stone, vinyl and rubber flooring tiles and other manufactured surface coverings. These eventually made their way into both domestic and public interiors, in a decorative as well as a functional capacity. In living rooms, showrooms and military installations, not only were flora and fauna being transformed into decorative and camouflage motifs but natural products, such as wood, marble and leather, could now be imitated by manufactured materials like Formica and Naugahyde, and veneers like Realwood and Luxwood.[1] By the 1950s and throughout the second half of the twentieth century, artists had become interested in these materials and increasingly drew on them for inspiration, sometimes constructing their works entirely from them. By taking interior environments and the materials used in their construction as her subject matter, Cohen also draws attention to the way in which the boundaries between art and the banal often merge in the spaces of everyday life.

From 1970 Cohen's work has been inspired by various forms of commercial art, such as advertising and real estate photographs, as well as by diverse domestic and public architectural environments, and by postcards. While she was studying sculpture and printmaking in the mid- and late 1960s, contemporary artists such as Richard Hamilton, Andy Warhol, Richard Artschwager, Claes Oldenburg, Roy Lichtenstein, Robert Rauschenberg, Dan Graham, and Ian Baxter of the N.E. Thing Co. had already turned to the commonplace for their subject matter. Cohen shared with these artists a fascination with the objects, spaces and iconography of the everyday environment. Even artists like Donald Judd, whose works serve as an extreme counterpoint to the indifferent design and casual nature of mass-

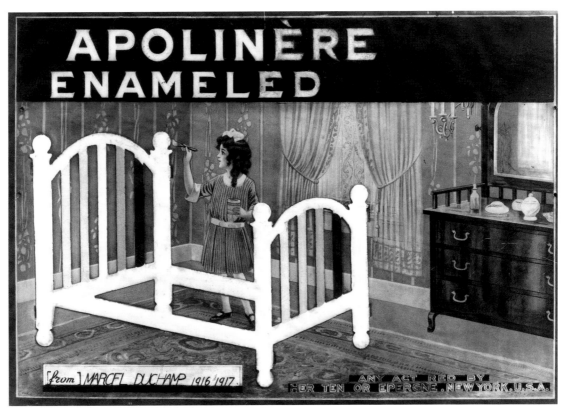

Marcel Duchamp, *Apolinère Enameled*, 1916–17

produced objects and architecture, were paying attention to the latter's ubiquitousness in the visual landscape in the mid-twentieth century. Reviewing an exhibition of Roy Lichten- stein's paintings in 1964, Judd commented on the pervasiveness of what he described as an environment of 'passive appreciation and opinion': 'Lots of people hang up pictures of sunsets, the sea, noble buildings and other supposedly admirable subjects. These things are thought laudable, agreeable, without much thought. No one pays much attention to them; probably no one is enthusiastic about one; there isn't anything there to dislike. They are pleasant, bland and empty. A lot of visible things are like this: most modern commercial buildings, new Colonial stores, lobbies, most houses, most furniture, most clothing, sheet aluminum and plastic with leather texture, the formica like wood, the cute and modern patterns inside jets and drugstores. Who has decided that aluminum should be textured like leather? Not Alcoa, who make it; to them there is just a demand. It is not like any of the buyers think much about it. The stuff just exists, not objectionably to many people, slightly agreeably to many.'[2]

It is precisely these kinds of environments and materials that have inspired Lynne Cohen's photographs. Although Judd's commentary relates specifically to the United States of the 1960s, the process of radically altering our perspective on the nature of consumer culture through art had already begun early in the twentieth century, most notably in the work of Marcel Duchamp. By shifting commonplace articles – a bicycle wheel, a haircomb, a urinal, an iron – into the realm of art, either through modification of the thing itself or simply by authorial licence, Duchamp created a tension between two seemingly irreconcilable domains: ordinary objects and art objects. *Apolinère Enameled*, 1916–17 (above), is but one example of his 'readymades' in which an advertisement served as the initial source of inspiration. As

Robert Lebel commented in 1959, 'Duchamp's "ready mades" have long been a part of our modern experience. They have even been accepted by those who do not know what they mean and have never heard of their author.'[3]

Cohen's large body of photographs, made over a period of thirty years, offers an important contribution to this theme in art. Ingenuously presented as neutral 'mirrors' of the world around us, they extend what Duchamp's readymades achieved earlier in the twentieth century by challenging the boundaries of credibility, by disorienting the familiar in everyday life and by disrupting the traditional values of art.

Besides responding to Pop Art and Minimalism, Cohen was engaged in various activities in 1969 and 1970 which would eventually lead to her decision to make photographs. Living at the time in Michigan, she was discovering places that she found so extraordinary that her first idea was simply to rope them off and direct people to see them, as the contemporary Belgian artist Guillaume Bijl does today. She was finding equally stimulating depictions of similar environments in how-to-do-it books and consumer and mail-order catalogues. The 'found-object' quality of these images appealed to Cohen, reminding her of Duchamp's readymades. 'As banal as they were, as ordinary as things looked in these catalogues, they were unbelievable… People's living environments looked like they were installations, looked like they were readymades, looked like they were works of art, looked like they couldn't be true.'[4] Cohen traced the outlines of these illustrations of domestic interiors and consumer products on to paper, which she later used as a basis for etchings and silkscreen prints.

Also in the domain of found objects were picture postcards, which have always been fundamental to Cohen's work. On her travels she sends friends postcards of shopping centres, golfing greens and other nondescript places. *Front and Back*, a 16mm film which she made with Andrew Lugg in 1972 uses found postcards as its theme. It shows both her attraction to the imagery and formats of postcards and her interest in their written messages and the latter's often curious relationship to the images they accompany. The messages, which in the film are read simultaneously with the projection of the postcard images, often reveal the disjunction between travellers' hopes and dreams and the reality they encounter. 'I've been here nearly twenty-four hours and at no time have I seen any more than shown here.' And 'We did the art museum today in twenty minutes flat. Maybe o.k., but we do not appreciate art. The circus grounds aren't open. That would be where we shine. Weather swell. Mom.' The imagery in *Front and Back* focuses on postcards that feature the banal rather than the memorable: exterior views of plain motels, the facades of corporate buildings, a Greyhound bus terminal, a hotel room, the main street of a small American town, a swimming pool, a university lobby with a mural in which mathematical symbols appear as decorative motifs…

It is not surprising therefore to learn that in 1971, the year before *Front and Back* was produced, Cohen had already started to work seriously in the medium of photography. From the beginning she would incorporate into her photographs the formal language of the imagery that attracted her in both mail-order catalogues and picture postcards: unaccented lighting, uniform depth of field and self-consciously neutral composition. Photography permitted Cohen to capture the aesthetic of this imagery and to use the camera to 'rope off' and give edge definition to places that excited her. It led to a more direct interaction with the world, one which promised to be 'more social, more political, more interesting, more dangerous'.[5] In

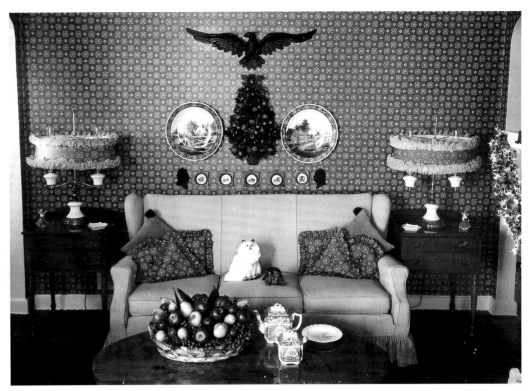

Richard Hamilton, *Just what is it that makes today's homes so different, so appealing?*, 1956

Lynne Cohen, *Living Room*, 1971

contrast to the working environments of street and landscape photographers, whose spaces lie within the public domain (and whose only constraints come in the form of camera-shy strangers, inaccessible viewpoints and inclement weather), the environments which Cohen photographs have to be penetrated. A complicated process of letter writing, faxing and tele-phoning is necessary to gain access to schools, spas, military installations and other sites. Even negotiations for access to domestic spaces – the subject of her early work – were often arduous, requiring well-honed diplomatic skills.

The question that forms the title of Richard Hamilton's famous collage of 1956: *Just what is it that makes today's homes so different, so appealing?* could equally well apply to Cohen's first serious photograph, *Living Room* (1971), also known as 'The Phillips's Living Room' (above right). While the differences in approach and realization are striking, both works are witty commentaries on popular domestic culture of the mid-twentieth century. Each presents the room as a stage-like setting in which furniture and pictures seem like props, the main difference between the two works being that Cohen's depicts the interior as a found object while Hamilton's shows it as a compilation of many found images. With its decorative plates centred above the couch, its knick-knacks marshalled into a compulsive symmetry and its wallpaper motif spilling over from the wall surfaces onto the covering of the lampshades and cushions, almost everything in the Phillips's living room has been turned into decorative pattern – functional objects no less than non-functional ones. It is a space so complete in its arrangement and content that it seems to have been designed with a photograph in mind, and indeed its quality of 'camera-readiness' and its two-dimensional appearance lent themselves well to the large-format camera's capacity for capturing both spatial volume and specificity of detail. Even at this early stage in her work, Cohen was intrigued not only by the 'found object'

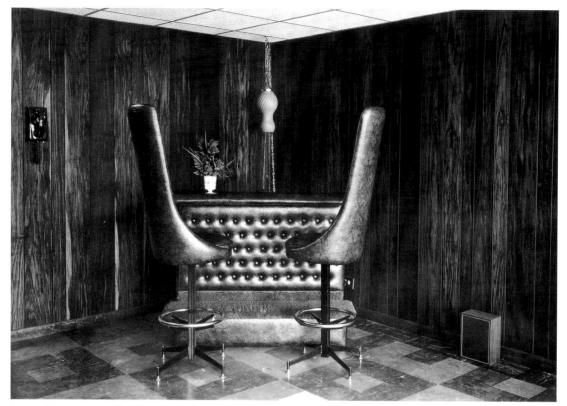

Lynne Cohen, *Recreation Room*, 1971

nature of these places – whether consciously or perfunctorily conceived – but also by the materials from which they were constructed. The large-format camera also made it possible for her to note precisely the differences between the surfaces of plywood and wood panelling, Naugahyde and leather, as in the early work *Recreation Room*, 1971 (above).

The sensibility behind the images Cohen made before 1982 was primarily formed by Pop Art. Everyday things are given other functions, as in *Office and Showroom*, 1980 (page 142), where the walls are lined with linoleum samples that mimic courses of brickwork and take the shape of one-dimensional briefcases. In other photographs sombreros become lightshades, and a giant Tyrolean hat illuminated by a spotlight takes on the appearance of a sculpture (page 48).

Cohen is frequently asked when she will start to photograph people. This seems to be a question peculiar to the medium of photography – as Cohen rightly points out, it is not one that a painter would be asked. But while her photographs do not include human beings, they are on occasion more revealing about human behaviour than any group portrait. Indeed, few photographs with people in them provide such truthful images of the choices we make about the places in which we live and work.

Paradoxically, in Cohen's early work human presence is often felt through its absence. When clustered together, empty chairs, with their obvious fashioning after the forms of human anatomy and their strategic placements, hint at conversations both past and future. And in some photographs the human figure is represented in cartoon form, or as a slender silhouette shaped out of plastic and suspended from the ceiling or painted on a wall (opposite).

In the mid-1980s, and into the 1990s, human figures began to appear in Cohen's interiors as skeletons, targets or dummies – the latter is particularly well illustrated in *Laboratory*,

1990 (page 119), where the dummies are reminiscent of the work of Edward Kienholz and George Segal. But her images do not depend on the inclusion of human figures in order to communicate a potent message about human existence. Her *Classroom*, 1988 (page 116), is an anatomy lesson for the late twentieth and the twenty-first century, just as Rembrandt's *Anatomy Lesson of Professor Nicolaes Tulp* (1632) or Thomas de Keyser's *Anatomy Lesson of Dr Sebastiaen Egbertsz. de Vrij* (1619), with their interiors suppressed into a backdrop of darkness to highlight the human drama, were anatomy lessons for the seventeenth century.

Whether producing contact prints or enlargements, whether working in black and white or colour, the formal aesthetic of Cohen's work has over the course of almost thirty years remained invariable. Photographing from a consistent distance, using a uniform light source and precisely framing the image in the ground-glass with an emphasis on detail, she has produced images that seem almost like reflections in a mirror. Although major changes have taken place in her work over the years, its formal consistency is striking, each shift of emphasis and transition from one approach to the next being so subtle as to be sometimes barely discernible.

While her determination to focus exclusively on interior space has never wavered, Cohen's approach to her subject matter and her way of presenting her images have undergone radical changes. She has at various points abandoned certain types of interiors. In the late 1970s

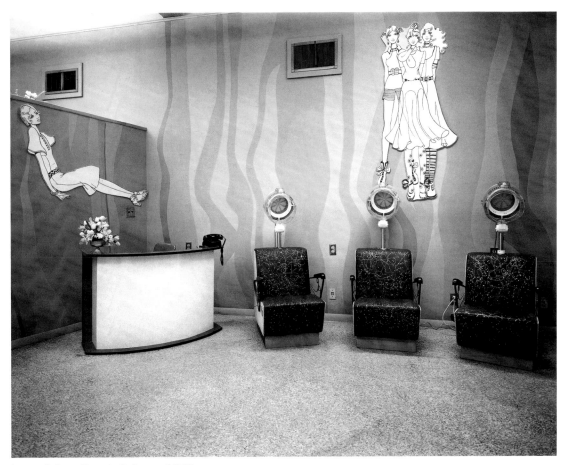

Lynne Cohen, *Beauty Salon*, c. 1976

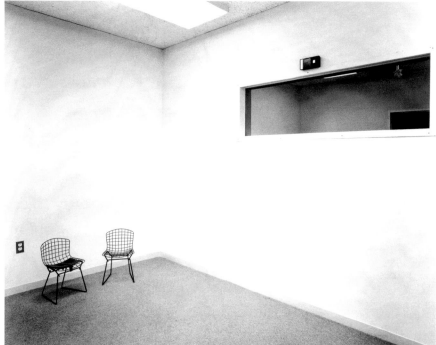

Lynne Cohen, *Classroom*, 1983

Lynne Cohen, *Laboratory*, 1983

she stopped photographing domestic spaces. Her images of observation rooms were restricted to the mid-to-late 1980s. Furthermore, there has been a process of gradual refinement of the types of classrooms, spas and laboratories she chooses to photograph. While the decor of the spaces she is currently photographing is increasingly minimalist, the content of the images is, unexpectedly, increasingly layered. Also, along with the changes in her subject matter, there have been major changes in the format of her prints and in their method of presentation that have given new meanings to her work.

Perhaps the most radical new development in Cohen's photography took place in 1982 when she began to enlarge her negatives, giving the print itself a more commanding presence and creating images that invited the viewer to enter into the space. By this time she had started to focus specifically on police schools, military training classrooms, practice target ranges, psychology laboratories and observation rooms in university psychology departments, all of which acquired in the enlarged prints a strong political edge. As Cohen put it, in this format her prints 'were much less precious...[and]...more threatening in the way that I think I felt about the subject'.

Cohen's early background in sculpture had always revealed itself in the monumental quality of both the objects she photographs and the spaces, as well as in her detailed rendering of material surfaces. From the early to mid-1980s up to the present she has stressed the significance of this sculptural aspect of her work by enlarging her negatives to make prints that occupy space as well as address it, and by placing these large prints in Formica frames, a strategy that reinforces the 'object' quality of her images. By changing their format and presentation, she could make her images less like windows onto the world and more like sculptural objects. Although they continued to share with the earlier contact prints an exquisite, lucid quality, the enhanced presence of the objects and spatial volumes in these enlarged images made them threatening rather than amusing.

Despite their menacing tone, however, the images retain much of the wit and humour that has always characterized Cohen's work – the air of menace has simply made the serious implications of the message clearer. The spirit of playfulness has become more iconoclastic, underscoring the apparent absurdity and irrationality of the decisions that led to the design and construction of many of the places she photographs. *Classroom*, 1980, which alludes to Jasper Johns's *Target with Plaster Casts*, 1955, is an example of Cohen's continuing to photograph certain objects and spaces because they recall iconic works of mid-twentieth-century art. In *War Game*, 1987 (page 65), the clumsily scripted sign, 'Play at Your Own...', on top of a sculptural assemblage of sandbags, alludes to the common analogy between war and play, but the paint splatterings on the walls make witty reference to the paintings of the US artist

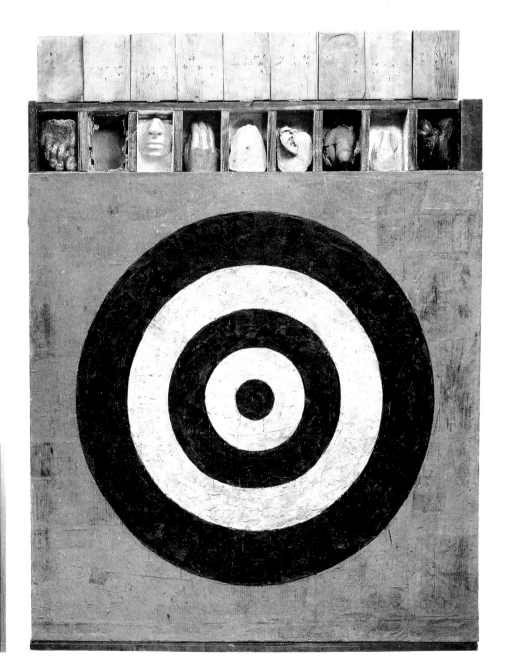

Jasper Johns,
Target with Plaster Casts, 1955

Lynne Cohen, *Classroom*, 1980

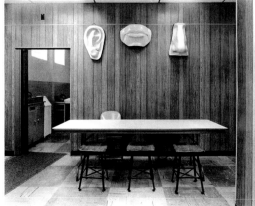

Claes Oldenburg,
Bedroom Ensemble, 1963

Lynne Cohen, Classroom, 1985

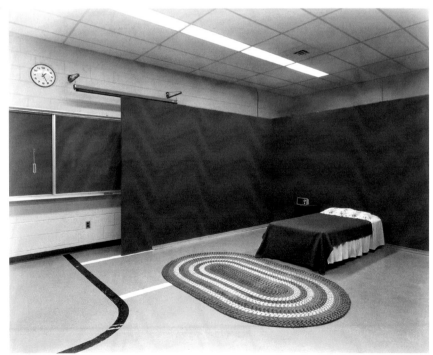

Larry Poons, whose work Cohen admires. And who can look at *Classroom*, 1985 (opposite below), which shows a bedroom replete with homey rag throw rug and side table, curtained-off and situated in the corner of a typical classroom, without thinking of contemporary art installations in museums, like Claes Oldenburg's *Bedroom Ensemble* (opposite above)?

Although Cohen continued to photograph classrooms, laboratories and spas into the 1990s, the differences between these spaces began to blur. Laboratories started to resemble spas; spas took on the appearance of laboratories. Whether in black and white or in colour, the images not only became even more spatially assertive but also began to play more on the senses. *Spa*, 1991 (page 93), is one example. With its faceted central column, from the bottom of which narrow rubber ducts open on to small stools, the room the photographer has depicted certainly piques our curiosity about scale and function, but it also evokes the touch of Latex and the sound of water being suctioned through it.

For many years Cohen had resisted working in colour, feeling that viewers knew already that 'the Naugahyde was either orange or beige'. But in 1998 she realized that there was something she wanted to say about colour – nothing to do with its ability to heighten the 'true-to-life' appearance of the spaces she photographed, or with its picturesque or graphic characteristics, but rather with its synthetic and chemical nature, and the properties that make it as 'unnatural' as plywood, aluminium, foil or styrofoam.

In *Spa*, 1999 (page 134), the saturated, chemical blue of an indoor pool acquires a depth and weight that make it just as important as the objects and the space are to the image's meaning and power. Indoor and outdoor swimming pools were originally painted blue to imitate the reflection of a blue sky on the surface of water, but this blueness seems now to have exceeded its original intention and to have become a self-contained experience of a particular range of 'blueness'. And in this image the blue of the pool rises like a chemical haze into the atmosphere, dissolving even the surface plane of the water. The only natural element to appear is the early growth of mould where the tiled ceiling and walls meet. As with the black and white photograph of the spa with the tinfoil-covered bed (page 68), it is difficult to reconcile the claustrophobic space with any notion of physical healing.

In *Hall*, 1999 (page 131), found in a conference centre, we see an enormous partition wall divided into a grid of gradated putty grey and creamy pink rectangles, as though a designer's paint swatch had itself become the wall's decorative motif. The combination of the room's coloration and the flat lighting creates an atmosphere of airlessness. The rather arbitrary, irrational creation of such a space is reinforced by still visible traces of the room's construction. The uneven heights of the doorknob on the frame where the partition wall is open and a lock at the upper edge of an adjacent door suggest users of incongruously different sizes – it is almost a wonderland for a twenty-first-century Alice.

Laboratory, 1999 (page 110), seems to be the most restrained of Cohen's works in her recent colour series, appearing at first glance to be almost monochromatic. On closer inspection, however, it could pass for a Hollywood set: the room's proportions suggest an epic, larger-than-life narrative. Viewed from close up and oriented towards the large, open room that has been photographed through two-way glass observation windows high above the laboratory classroom itself, the architecture reveals elements of bewildering proportions. A door located in the centre of the back wall appears to have been made to accommodate an animal

of Brobdingnagian scale, while the tracks running along the ceiling's centre are presumably for hauling cadavers to a rack in the foreground. The openings and furnishings that flank this giant doorway look miniature by comparison. In composing her picture of this hermetic, clinical environment, Cohen has performed the wonderful sleight of hand of capturing a glimpse of the outside world through a clerestory window in the upper-right-hand corner of the image. With the soft-focus monochrome of a photo-secessionist image, this picture-within-a-picture shows the branches of a few imprecisely delineated trees pressed against the glass, and serves to confound, once again, our sense of scale.

In three decades of examining and depicting interiors, Lynne Cohen has created an in-depth archive of images that address many aspects of our culture, from her early, formally complex contact prints, which were precisely seen and superbly rendered, and which yielded their meanings readily, to her later austere, more darkly funny enlargements, with their many-layered meanings. It is perhaps misleading to talk about this work as an 'archive', since it is not documentary, and is clearly as much about art-making as anything else. But how else does one ascribe a value to the impressively large and deep body of images she has assembled on the subject of interior spaces? This inspired and steadfast engagement with her subject and the extraordinary images it has engendered are unique.

Consumer culture has placed a high value on product variety, and television programming and spot commercials demand only seconds of our time in order to get their 'message' across. It is thus doubly refreshing to encounter an artist who has had the courage to reject the idea that in order to hold the viewers' attention all one has to do is develop a new subject. Accepting the discipline of exploring her subject matter in depth, Cohen has come to understand its complexity and has created a visual language of her own in which to communicate it. The parameters that circumscribe her working method are more often encountered in the world of scientific enquiry, where the same problem can be worked on for an entire lifetime.

The qualities of originality and formal brilliance that so strongly mark Lynne Cohen's vision have never declined into mannerisms or caricature. Since 1970 there has been a steady development of ideas and a constant reconsideration of aesthetic premises, which have earned this photographer's works a special place not only in the history of photography but also in the art of our time.

NOTES

1. In the August 1943 issue of *Architectural Record*, Formica was touted as the product bar none in the 'Dream Halls of Tomorrow': 'If the hall of your particular dream is a sandwich bar, school or factory restaurant, hotel, theatre, store, bank or public building requiring table, counter or furniture tops, interior paneling or outside decoration you'll find Formica the material of your dreams.'

2. Donald Judd, 'Roy Lichtenstein', review of exhibition held at Castelli, 24 October – 19 November, in 'In the Galleries', *Arts Magazine*, December, 1964, p. 146, republished in *Donald Judd: Complete Writings, 1959–1975* (New York and Halifax: The Press of the Nova Scotia College of Art and Design), 1975, p. 146.

3. Robert Lebel *et al.*, *Marcel Duchamp*, Paragraphic Books, New York, 1959, p. 35.

4. Interview by William A Ewing, Lori Pauli and Ann Thomas with Lynne Cohen, 25 October 1998.

5. Interview by William A. Ewing, Lori Pauli and Ann Thomas with Lynne Cohen, 25 October 1998.

Camouflage: An Interview with Lynne Cohen

During the last thirty years or so you have produced a remarkably consistent body of work, but there have been a number of subtle changes in your photography during this time. Can we begin by talking about these?

The shifts in my work are partly due to my exploring different subjects. The men's clubs, halls, beauty salons, living rooms and lobbies I photographed early on are much more commonplace and accessible than the target ranges, classrooms, spas, military installations and training environments I now photograph. In the new pictures, there is a more critical edge because I have become more concerned with manipulation and control. Still, my photographs from the beginning have been about various sorts of artifice and deception. I

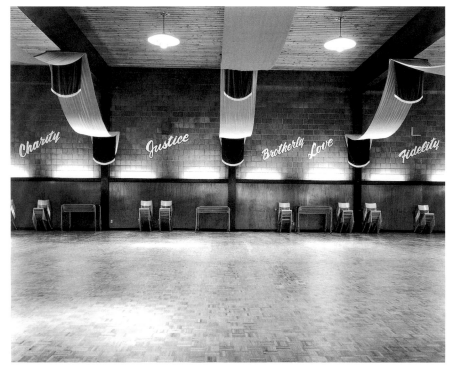
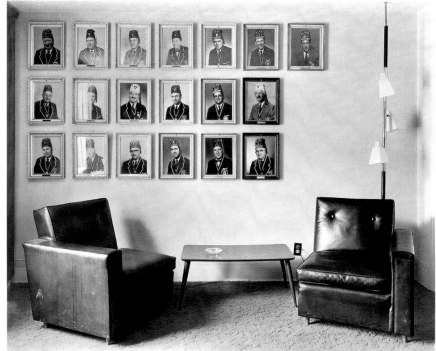

Lynne Cohen, *Men's Club*, mid-1980s Lynne Cohen, *Men's Club, c.* 1977

started out probing the boundaries between the found and the constructed, the absurd and the deadly serious, the animate and the inert, and I've been probing them ever since.

There are certain recurrent themes in your work. Which, in your own view, are the key themes, and do you see any particular images as pivotal?

The men's clubs, especially the picture of a room with the words 'Liberty, Brotherly Love, Fidelity' on the wall and the picture with photographs of men in hats like lampshades (above, left and right). *Party Room.* 1976 (page 48), was also pivotal; the floor is like an action painting, a record of all the scuff marks, scratches, scrapes. Then there is the classroom with the aeroplane simulator that looks like a gigantic toy (page 49). And some recent laboratories and spas. And some observation rooms.

The creepiest of all your themes, perhaps... Almost all your pictures are made indoors. Why is this so?

Almost everything I've done has been indoors, and the few outdoor pictures I've made look like indoor ones. The sky functions as a wall and it still feels as though there are no exits. But mostly I photograph inside. It demands much less editorializing. Composing outside is almost impossible without interfering with the found-object quality of things, and I prefer not to intrude in that way. Still, if you think of my work, as I often do, as a kind of installation art, the separation between inside and outside is not so sharp.

At one time you seem to have been obsessed with laboratories. Are you less so today?

The problem with research laboratories is that virtual spaces are taking over from real spaces with real objects, and I'm not interested in photographing computer screens. Usually, however, I stop photographing subjects when I don't have anything more to say about them. This happened with living rooms and later with the men's clubs and observation rooms. I become immune to them and would revisit them only if I came to think there was something new for me to deal with. Perhaps one

day I'll go back to some of the big party rooms I used to photograph. This time around, though, I'd focus on the linoleum floors and wall panels rather than on the Pop Art iconography. Something like this happened with the swimming pools in spas. In 1975 I photographed a swimming pool at a resort in the Poconos, the honeymoon capital of the USA. The pool had mould oozing down the wall, even though it was supposed to be a luxury hotel, and similar stains appear in some of my later pictures of pools. I hadn't thought of the mould as the primary theme until I saw it again in a different context with something else in mind.

Do you think you are doing something different from documentary photographers who record subjects almost encyclopaedically?

My goals are not as noble as theirs. I have little interest in collecting examples of places for historical, sociological or anthropological purposes. And I don't see myself as a documentary photographer. Of course my photographs document places I go to. But they are also documents of what I am thinking about, resonances between what is in the world and what is in my head. I don't photograph streets, industrial sites, people in their homes for their own sake and rarely feel compelled to capture the essence of the places I visit. Often there is only one thing that interests me. Sometimes nothing at all. The documentary photographer's job is to record something. It isn't mine.

That's evident in the very fact that you don't even know what you are going to find when you go into a new site. That must be terribly exciting, that anticipation, that hope that you are going to find something truly extraordinary. It really is an adventure for you, isn't it?

It would be stretching it to say it is an adventure but I often find it exhilarating. For me the process of making a picture involves dealing with strangers and going to places I've never been to, and the anticipation and intimidation are part of it. I sometimes describe myself as a performance artist because of what I have to do to get access to places I want to photograph. It was much easier to find and get into people's living rooms. I could sometimes see them from the road. That's not possible with institutional spaces. They are nearly always behind several sets of doors, often without windows. There's no more window peeping.

So the process of making pictures somehow determines how they look, at least in part?

There is a subplot connected with getting into places. It's not obvious in the pictures but it's there all the same. At some point the viewer asks: 'How did she get into or out of this place?' I prefer to allude to things and leave it to the viewer to fill in the details. Like Brecht and Godard, I want the audience to do some of the work. For me it is best when the viewer goes back and forth and regards the photographs as documents, as constructions, as pictures with social and political messages. They don't have to be only one thing, and I'd rather not tell people how to read them.

Would you be disappointed if people missed the humour and surreal aspect of your work? Imagine somebody looking at the Phillips's Living Room (Living Room, page 13) and saying 'I'd like to have a living room like that'?

If people didn't find the places I photograph a bit, shall we say, bizarre, I'd wonder about them! People think the Phillips's Living Room, which I did very early on, is a celebration or a critique of bad taste, but I've never been much interested in kitsch. Like many of my other pictures, this one is about

symmetry and boundaries, about the absurd, about the uncanny way rooms look like installations. Of course the photograph has a critical edge. There is an awful lot of shag carpet in the pictures of living rooms I made in the early 1970s, something I have a visceral reaction to. In my more recent work, the materials are different and I don't respond to them the same way. The stainless steel in the picture of the experimental chamber (page 130) is so cold you can feel the metal in your fillings.

True, it must be twenty below zero in there. That's another picture one can easily imagine as an artist's installation. But in fact, you seem more interested in naively created spaces than, say, in the spaces you find in museums and art galleries.

I used to be interested in ordinary, even banal, places but I'm not any longer. Laboratories, spas, military installations and classrooms are not naively constructed. What bothers me about spaces in museums and art galleries is not that they are created by sophisticates but that they have already been framed. They are not raw, and I feel I should stay clear.

Often someone has put a desk in a central position of authority, or added some decoration on the wall. Is that where people come into your pictures, through the invisible hierarchy of who sits where?

The positioning of the furniture makes it crystal clear who is in charge. It draws a line between them and us. But it isn't only how the furniture is arranged. Couches and chairs look like people, and there are many other suggestions of the human body: dummies, diagrams and silhouettes. Also there is often an eerie human presence or a hint of an activity just finished or about to begin.

Eerie, and yet you are drawn to just such places. How do you explain this attraction?

I have an approach/avoidance reaction to them. Sometimes I find them seductive, sometimes repulsive, but mostly I have mixed feelings. Perhaps it would be best to say I'm drawn to visual and ideological contradictions and deceptions. I'm fascinated by boundaries that are more conceptual than real, by ambiguous messages, by things that don't make sense, by bad logic. It is strange how frequently things aren't quite what they're cracked up to be – how often pictures of exotic places are unconvincing, how often luxury resorts resemble psychiatric hospitals and how often psychiatric hospitals look like health spas. The picture of a blackboard with a diagram of arrows going in two directions (opposite) sums it up for me. Is it a sketch for a bizarre philosophy of life?

Or perhaps a mirror of moral or cultural confusion? What seems most sinister about your work is not the laboratory specimens half hidden behind a cupboard or the dead monkey draped over an operating table, but the sort of places you photograph.

There is less air in the classrooms, laboratories and military installations than in the beauty salons and halls. The places are still amusing but there's a more sinister aspect. It is much less clear how you get into or out of them. Perhaps laboratories that smell of formaldehyde are more threatening than living rooms that smell of baby powder and air freshener. But both can be asphyxiating.

Sometimes it seems as though you are more interested in small details than in the big picture.

I'm intrigued by architectural details and hardware. It's strange, but I've never seen an electrical outlet that is level. There are people travelling around in spaceships but no one can properly install an outlet. Some people might find this consoling but I find it disturbing. Also I'm acutely aware of

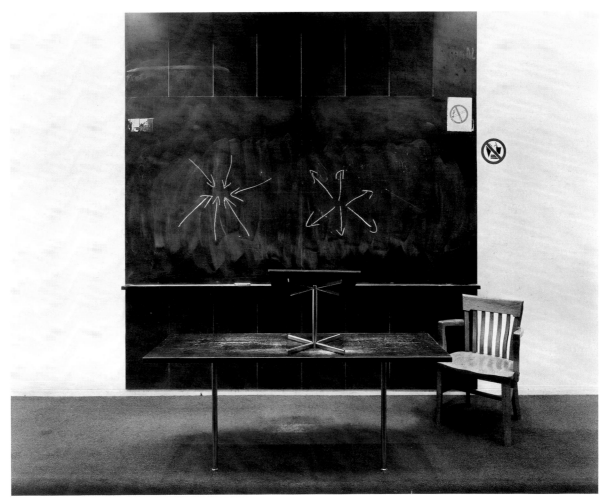

Lynne Cohen, *Classroom*, mid-1980s

things like surveillance cameras, 'No Exit' signs, fire alarms and grimy stains around light switches. Sometimes objects look pathological, sometimes not. It often seems as if someone could be shouting at me from the other side of the air vent. And why do heating units so often seem to be keeping an eye on things? They have peculiar human attributes – they seem to want to join in rather than just sit there. Things like that amuse me: outlets, exhaust grates and office paraphernalia that looks like minimalist sculpture. Sometimes the hardware speaks for itself; but sometimes it functions as a metaphor for something else. Every room is a conceptual piece, an installation in real time.

You often mention the word 'installation'.

It pleases me that my pictures have been taken to be installations I've set up. People often say, 'You must have constructed them. They can't be true.' But obviously I couldn't have fabricated the spaces I photograph so seamlessly, to say nothing of the fact that the force of the work would be diluted if it weren't mostly true. I sometimes clean things up a bit. I occasionally move something into the frame or remove objects that are distracting or clumsy. But these 'assists' don't change the meaning of the pictures. What I photograph is in the world more or less as I find it. But I admit that if you photograph fragments of reality the way I do, the results are pretty much bound to look constructed.

Do you think you could say what you want to say in any other medium?

The ideas I have seem to me best realized photographically but some could also have been worked

out as actual installations. In the early 1970s, I thought about cordoning off living rooms, halls and party rooms the way they do in natural history museums and at crime scenes. My idea was to choose a site and tell people where to stand and what to look at. Also I imagined appropriating goose-neck lamps, chairs with chrome legs and scuffed linoleum, and transporting them to an art gallery. They would have been photographs in real space. In the end I decided it was better as an idea and opted for the found environments.

There are a lot of references in your work to contemporary art and art history. Just how conscious are they?

There are uncanny affinities between what I photograph and what artists paint and construct. In my work you find Kosuth clocks, van Eyck mirrors, Beuys blackboards, Artschwager desks, Richter's famous men, Hatoum wire cages and many other reminders of early and contemporary art. A fixture in one picture looks like a Flavin, a fixture in another looks like a Judd. Someone once referred to my photographs as 'facsimiles from a virtual museum'. But they are no more facsimiles than they are documents. They are both and neither.

Discussions of your work usually focus on the kinds of interiors you photograph and on the strangeness of the places we create for ourselves. But the look of your work is also very striking.

When people discuss my work they tend to focus on the content and ignore the formal qualities, which for me are equally fundamental. Coming to photography from conceptual art and art and language, I felt the more deadpan the picture, the more likely it would appear to be about ideas. From the start I realized I could heighten the illusion of neutrality by flat lighting, symmetry and deep focus, the sort of devices used in the production of postcards and annual reports. This gives my pictures a cool, dispassionate edge. It makes them seem immaculately conceived while camouflaging the all-but-incomprehensible stories they seem to convey. My strategy is to deal with complicated themes in a way that creeps up on the viewer.

In some recent photographs it's hard to quite figure out where the light is coming from or how a shadow is attached to an object.

There is more light in the laboratory pictures than in the early interiors. It is curious how light can be palpable in a room that has no windows. In a recent picture of a military installation it feels as if the light is coming from behind you (page 98). Not knowing exactly the source of the light contributes to the ambiguity of a space. You vacillate between feeling the space goes on forever and feeling hemmed in.

In the picture of the section of the aeroplane (page 49), the picture with the Tyrolean hat (page 48) and many other pictures, everything looks somehow distorted.

In one way the distortions are linked to Pop Art. Early on I was drawn to the sort of exaggerations you find in the work of artists like Claes Oldenburg. The hat in *Party Room* is far too big for the room, and the room it is in is just bizarre. Everything is warped – and not just because the picture was taken with a wide-angle lens. Even the minimalist white-papered box the Tyrolean hat is perched on is wrong. All too often, the world seems to me to have been fabricated by an architect out of foam-core. The scale of things is nearly always off, and incidental things look monumental.

This sculptural aspect of your work is very intriguing. You began, in fact, as a sculptor and printmaker and then shifted to photography. How did this come about?

It was in the early 1970s, at the time of Pop Art, Minimalism and Conceptual Art. I was using material culled from how-to-do-it books and consumer catalogues and wondered why I shouldn't just knock on someone's door and ask if I could take a photograph. It seemed to me that the statement would not only be bolder but more engaged. Also, by moving to photography I thought I could make art in which the hand of the artist was absent, art that looked as though it had mysteriously appeared. Photography struck me, as it did a lot of artists then, as a medium without pretence. It didn't come with the art historical baggage of painting and sculpture. And its ideology was closer to Arte Povera, which I liked.

So you didn't have much training in photography?

I came to photography with pretty definite opinions about art, and the rudiments of the craft didn't take long to learn. Certain things would have been easier had I had more training but my time studying anthropology, philosophy, literature and such like wasn't wasted. It helped me get clear what I wanted to say. My real point of departure, however, was sculpture and art history. I was intrigued by Richard Artschwager's early work and his attention to Naugahyde, wood panelling and linoleum. I knew I wanted the viewer to be able to see the difference between plywood and polyethylene, and I started working with a view camera right away for that reason. I also knew I didn't want to photograph anything moving, which ruled out people. That's about all I knew to begin with. The history of photography was just part of my general knowledge of art history.

You often speak of Duchamp and the readymade.

When I was a printmaker, I regarded catalogue interiors as readymades. The more mundane they were, the more unbelievable they seemed to me. It was the same when I started to photograph. I found the banality of everyday life so loaded with meaning it was incomprehensible. The ephemera of people's living and work spaces had an obsessive order or disorder. From the first photographs I made, I felt the world couldn't be like this. It seemed as if it was full of finished works of art. You could say I saw myself photographing readymades. But while I appropriated a Duchampian attitude of neutrality to the formal strategies I employed, I have never been indifferent to the subjects I photograph, only ambivalent.

At a certain moment you moved from strict adherence to contact prints to enlargements. When were these earlier works begun, and when did you make the move to the larger prints?

I made the first picture I stand by in 1971. It is very different from my present work. For one thing it is more symmetrical. In those days I thought there was only one place to make a picture. It was as if paper footprints were stuck to the floor telling you where to stand. I don't think this now. The move to larger prints came in 1980. Once I saw the pictures larger, I realized there was no good reason to continue contact printing. The larger prints were less benign, and the subjects looked even more like constructions. Also, while the subjects in my work tend to push you away, the big pictures have a seductive quality that draws you in. It is harder to keep the larger photographs at a distance emotionally – they are like picture windows you can fall into. The bigness heightens the three-dimensional qualities and makes the viewer feel more a part of the space of the picture. This is

something I appropriated from art history. I use the sort of devices you find in Baroque painting to implicate the viewer physically and psychologically.

Nonetheless, there's a limit to the size you can move up to, isn't there?

The important thing for me is not so much the difficulty of making the pictures bigger as the fact that at a certain point the grain takes over and the picture falls apart. The photograph gets mushy and the edges flatten out. The oversize photograph of the spa with moving water and columns, the one that resembles a Fra Angelico painting (page 46), is bigger than some of the others, and I don't think it would be so unsettling if it had been printed smaller. But there is a limit. I want the pictures to open up when you look at them close to. There should be more rather than less to see.

Could you say more about the feeling of disorientation you find so important?

My work has always been about psychological, sociological, intellectual and political artifice. This is apparent in the early pictures, but in recent years it is clearer still. I am now more preoccupied by deception, claustrophobia, manipulation and control. This is most noticeable in the pictures of police schools with human targets, spas that look like forensic laboratories and training environments with no exits. I take my work to be social and political but there is no concrete message. Perhaps this is why I feel much closer in spirit to Jacques Tati than to Michel Foucault.

You clearly do delight in the absurd. Doesn't the framing you select in the camera heighten the sense that things are not quite stable?

I'd like to think how I frame a space doesn't disrupt what's there too much. Ideally, the viewer should feel the edges of the picture could be here or there or somewhere else. What the picture is about comes from the choice of subject matter and how it is turned into a photographic object. When the framing is seamless, the barrier between the space depicted and the room in which the viewer is standing dissolves.

Why did you resist dating your work for so many years?

This has been a bone of contention even with some of my strongest supporters. Mainly I didn't want the pictures to be about a particular place and time. I didn't want people to say: this is the 1970s, this is the 1980s, this is the 1990s. And I've always had a strong sense of life as a blip and of thirty years not counting for much in the big scheme of things. Probably what prompted me to start dating them was that I became more territorial. I wanted it to be known that I did something before someone else. In any event, it is not so hard to figure out what is early work (work between 1971 and 1980), later work (work from about 1980 to about 1990) and most recent work (work from the last ten years or so). You can tell from the objects. The pictures are a kind of archaeology of fixtures and furniture. There is no question as to when *Professor's Living Room* (opposite) was made. You can almost tell from the smells associated with the places. The early work conjures up smells of ashtrays filled with cigarette butts, empty beer bottles, Freon, wet dog hair and air freshener. The later work conjures up smells of chlorine, metal, electric wires, gasoline, plywood and formaldehyde. The smell of linoleum is a constant so this method is not entirely reliable. Also the early work is funnier, messier, more symmetrical, warmer and less threatening; the later work colder, tidier and more disquieting.

What prompted you to start working in colour?

When people would ask why I didn't work in colour, I responded that I did. In much of my black and white work there are clues as to what the dominant colour is. For example there's a picture called *Loan Office*, with a photograph of a racehorse and two pig-like chairs made of Naugahyde that simply has to be yellow-orange. Nobody needs to be told the colour of wood panelling, plywood and stainless steel. You can fill it in yourself. What prompted me to start working in colour as well as in black and white is that I became interested in the way colour film records colours wrongly. Once I let go of the idea of getting the colour right, I could set about capitalizing on the way colour film subverts the psychological weight we accord things in the world. Now what strikes me as peculiar is that the colour pictures seem to be made from much greater distance even when the same lenses and equipment are used. The colour acts like a distancing device, and the pictures appear to have been taken from miles away. I can't explain that.

Colour is a dimension fraught with implications for your work. In some cases it is so subtly deployed that it takes a moment to register that the image actually is in colour. There is even a danger that the colour can work against the function of the sites, is there not?

Yes and no. The laboratory pictures are filled with colour-coded paraphernalia – the coloured pipes tell you what they are used for and the coloured wires say something about electrical power. But this explains nothing. In fact it makes the spaces look crazier still. The laboratories look even more like

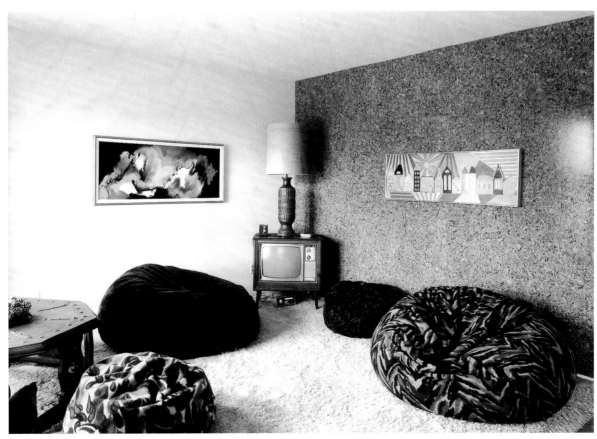

Lynne Cohen, *Professor's Living Room*, 1972

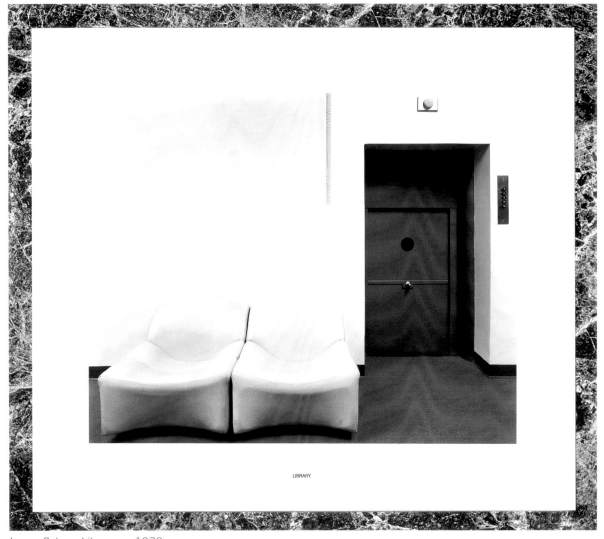

LIBRARY

Lynne Cohen, *Library*, c. 1978

obsessive installations or children's game boards. While the colour work is less ominous in one way than the black and white work, in another way it is more ominous. It's a bit like cotton candy. The smell is appealing but the stuff sticks to your face. The colour of the water in the therapeutic pools is the same. It is very seductive but it feels heavy, metallic, sickly.

You seem attracted to colours that have a sickly quality – the blue of pools for instance.
It's strange but I don't think about the colour before making a picture. It's just a fact. It is almost subliminal. Perhaps that's why some people who saw my first exhibition of colour photographs didn't realize that they were in colour. A few months earlier I exhibited black and white work alongside colour work and felt one led seamlessly to the other. You didn't know where the black and white work ended and the colour work began. The colour is not something I want to draw attention to. I want it to be as neutral as the other formal devices I exploit.

When you frame prints for exhibition, you see the frames as contributing to the pieces. That's unusual in a photographer. How did it come about?
In the mid-eighties it struck me that I'd like my photographs to function as three-dimensional objects as well as windows on the world. I thought I should make the frames resonate with the subject

matter of the photographs and bring out the link to my early work in sculpture. I decided on Formica because it is fabricated photographically, it echoes what is happening in the photographs and it adds another layer of illusion and artificiality. One *Spa* (page 93) is framed in marble that simulates the marble at the spa itself, a photograph of a Hercules 'bomber' mock-up was given a yellow frame because of its association with mustard gas, while a *Military Installation* (page 73) is framed in green to suggest canvas or camouflage. I think the resulting pieces are more complete as objects and the border between the picture and the world no longer so abrupt.

Your first book was called Occupied Territory *and this one is called* No Man's Land*. It sounds like war. Are things really that bad?*

Not really. Perhaps it's just that there's too much camouflage.

Interview conducted by William A. Ewing, Vincent Lavoie, Lori Pauli and Ann Thomas, February 2001.

THE PHOTOGRAPHS

Mixed Feelings

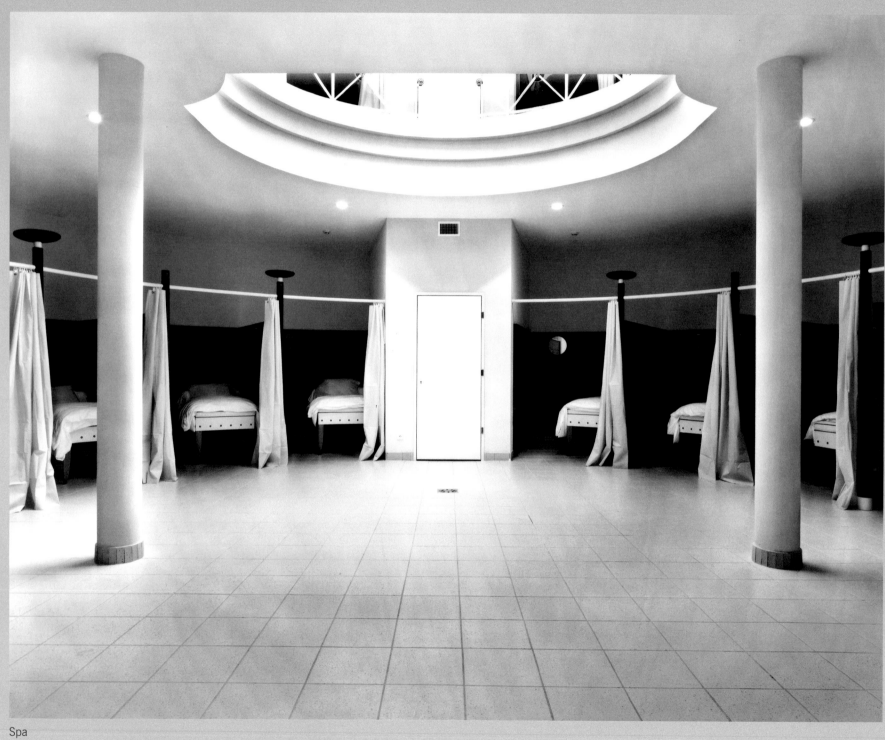

Spa

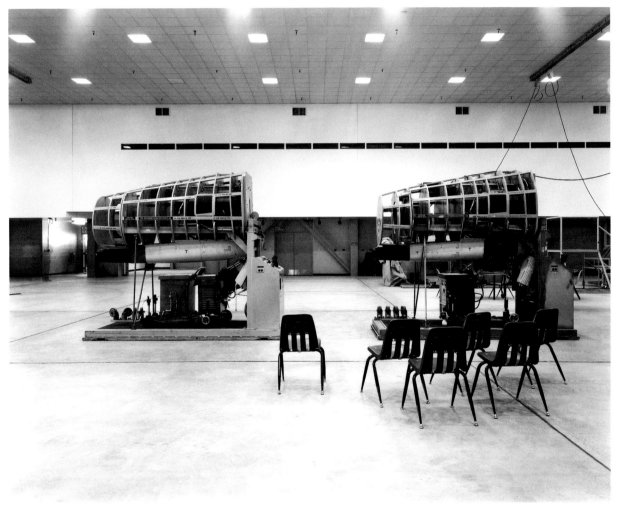

Classroom

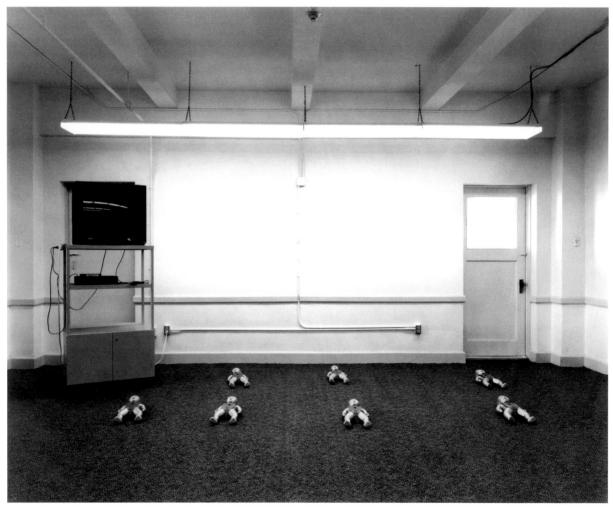

Military Installation

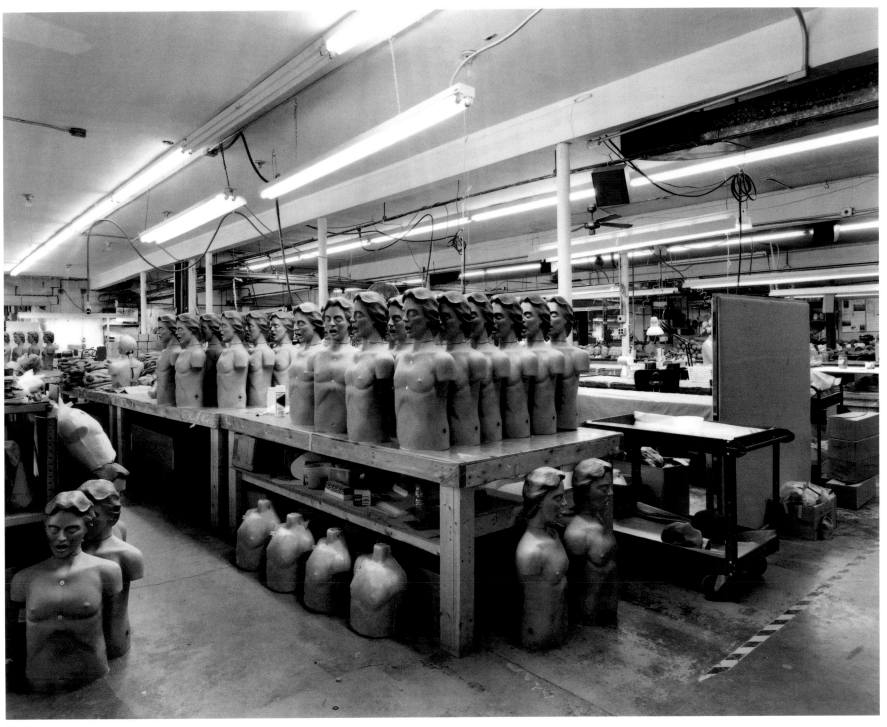

Factory

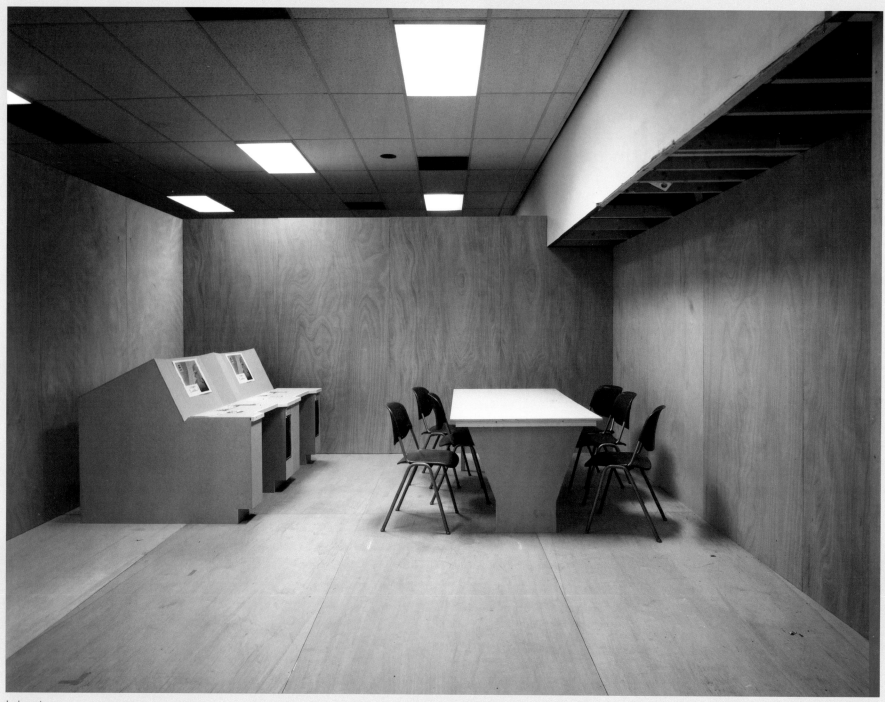

Laboratory

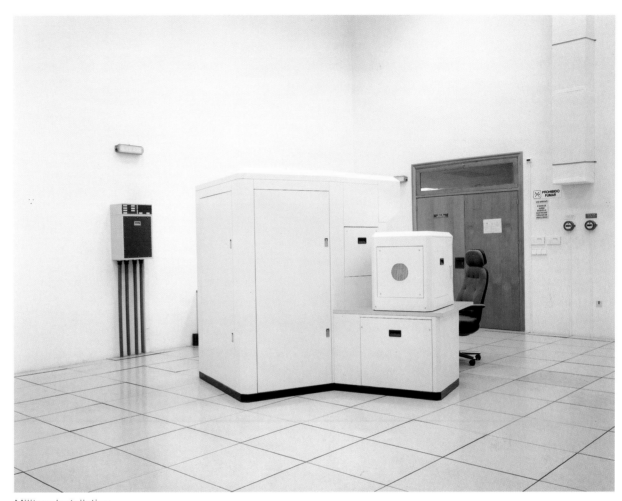

Military Installation

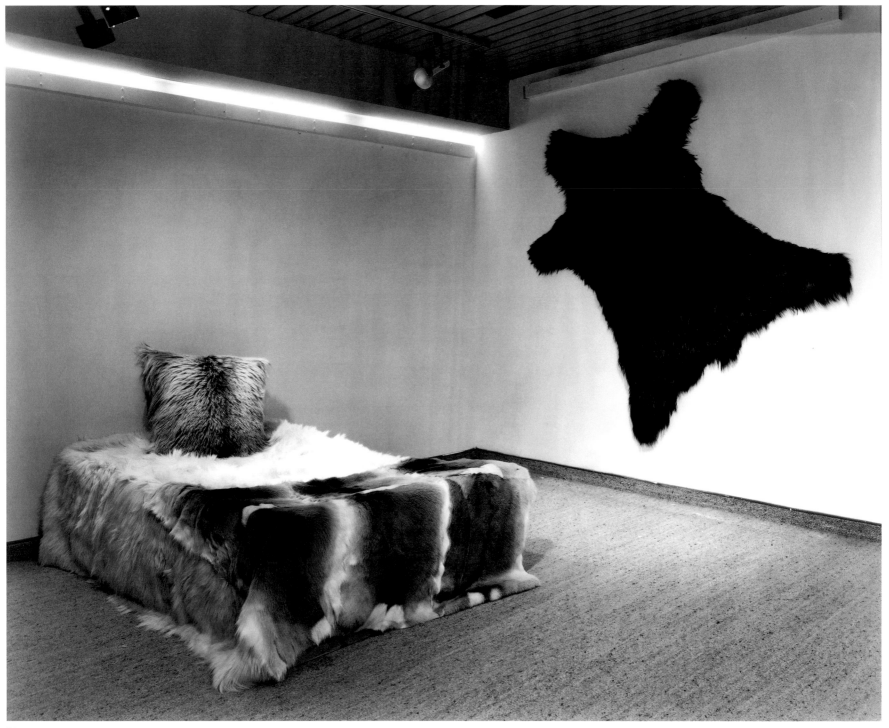

Showroom

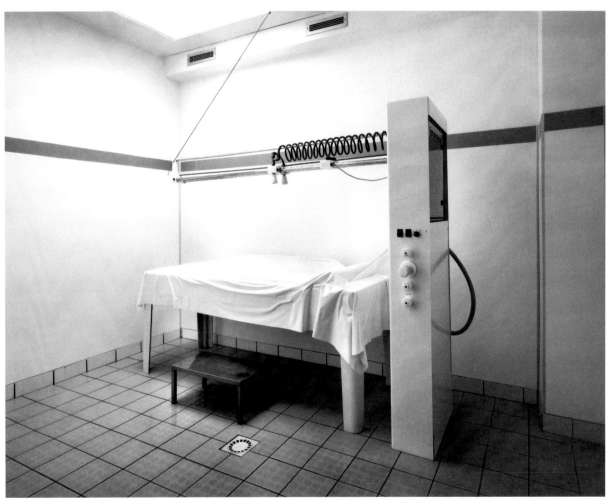

Spa

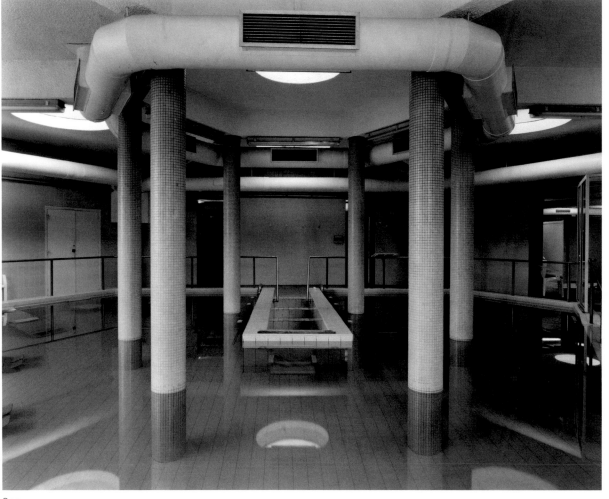

Spa

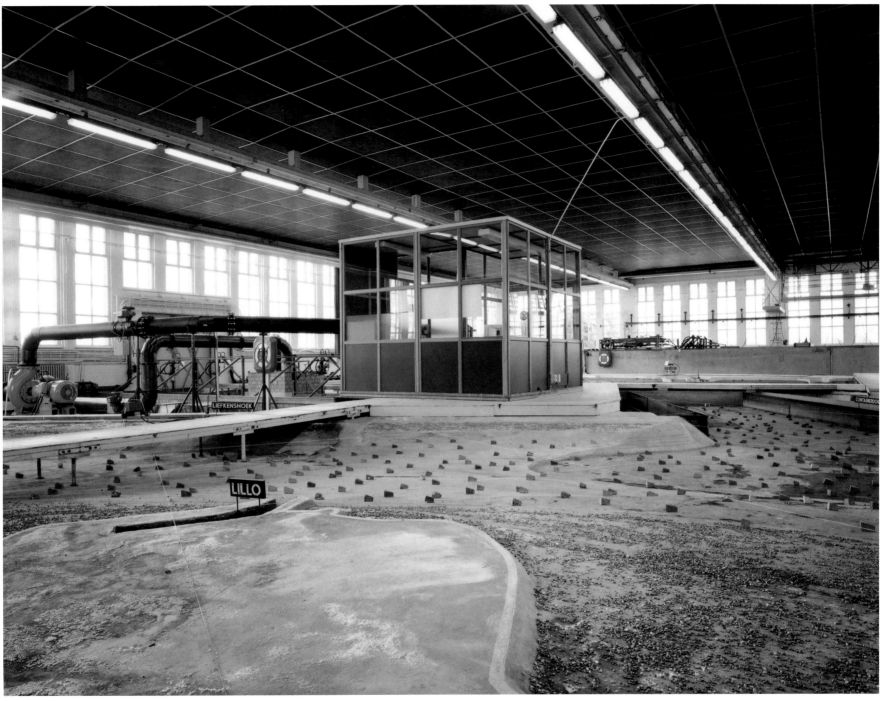

Laboratory

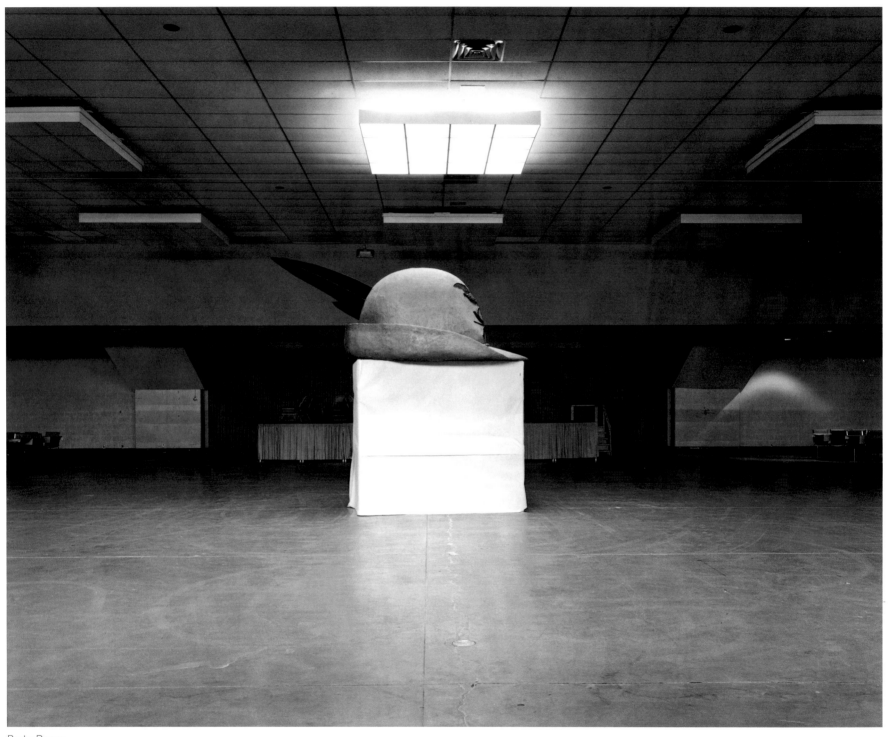

Party Room

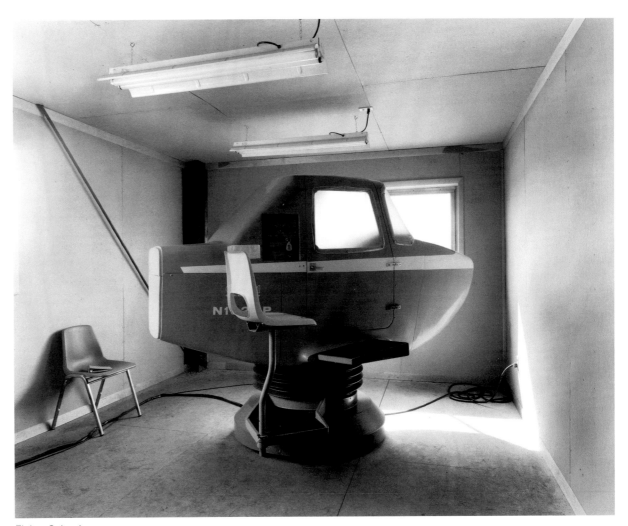

Flying School

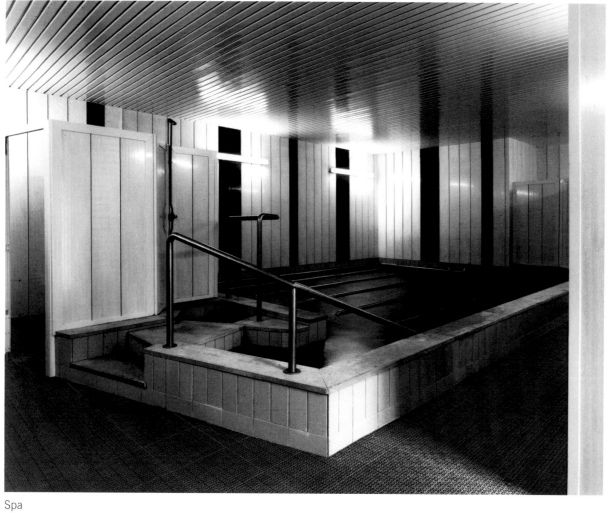

Spa

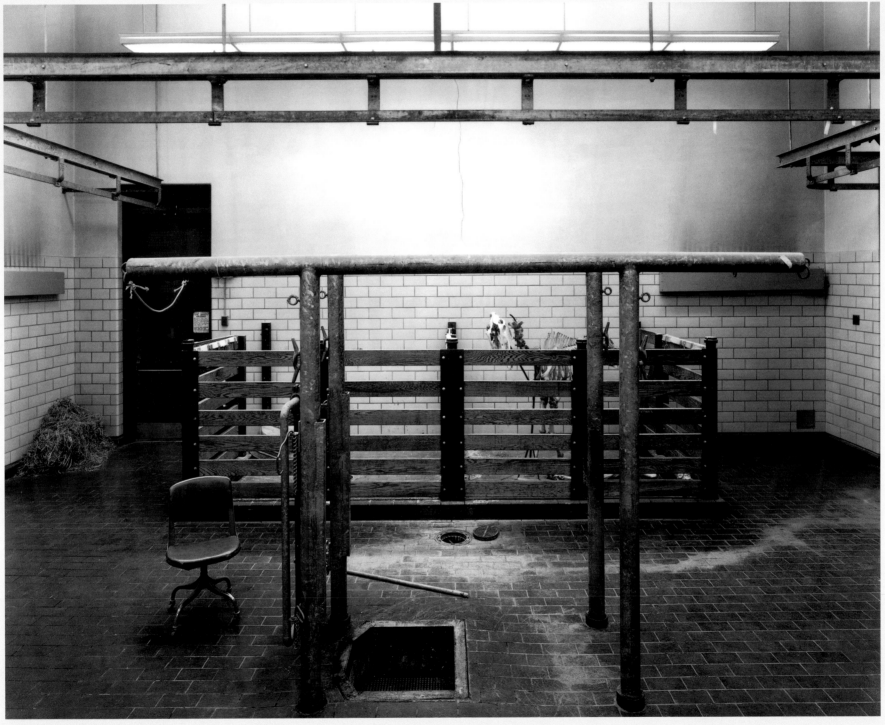

Classroom

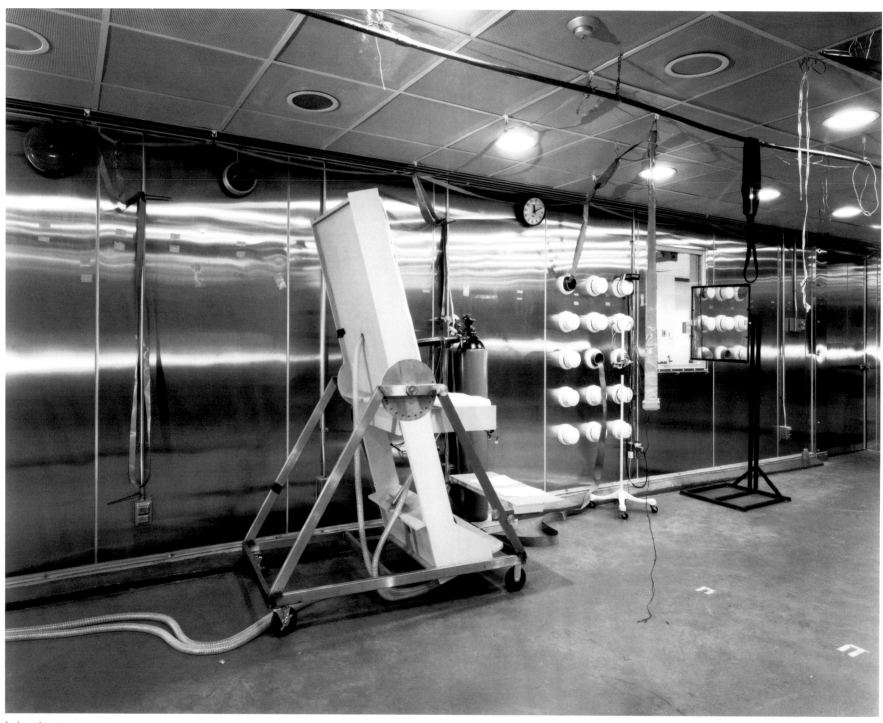

Laboratory

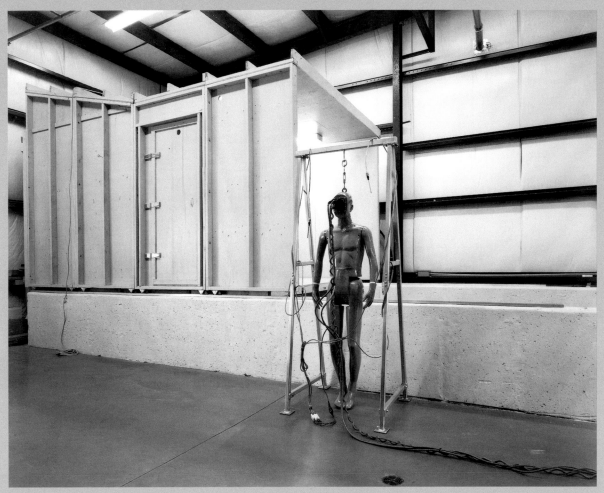

Laboratory

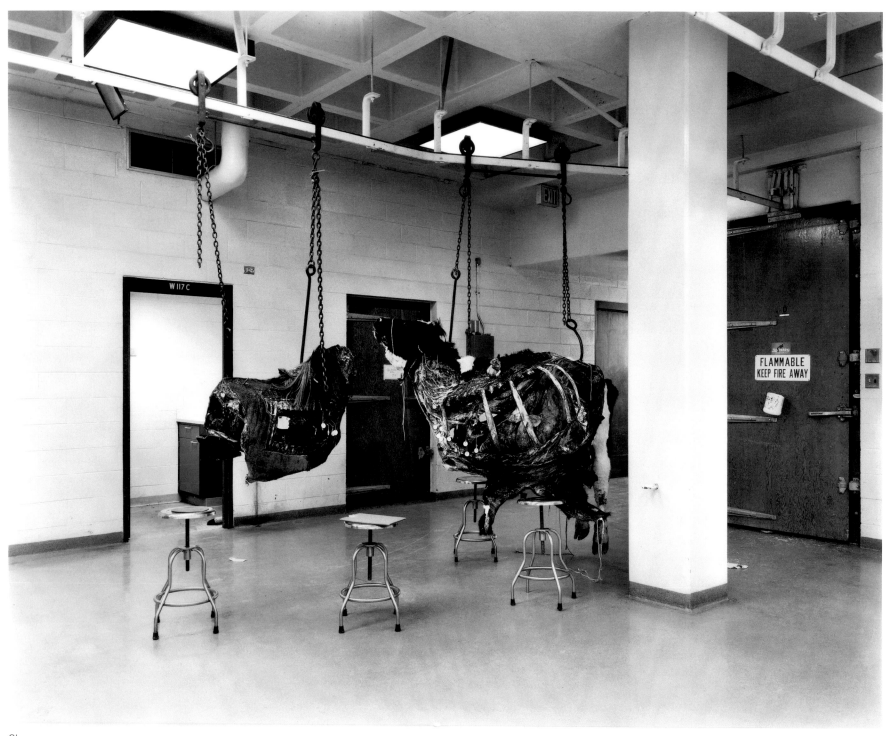

Classroom

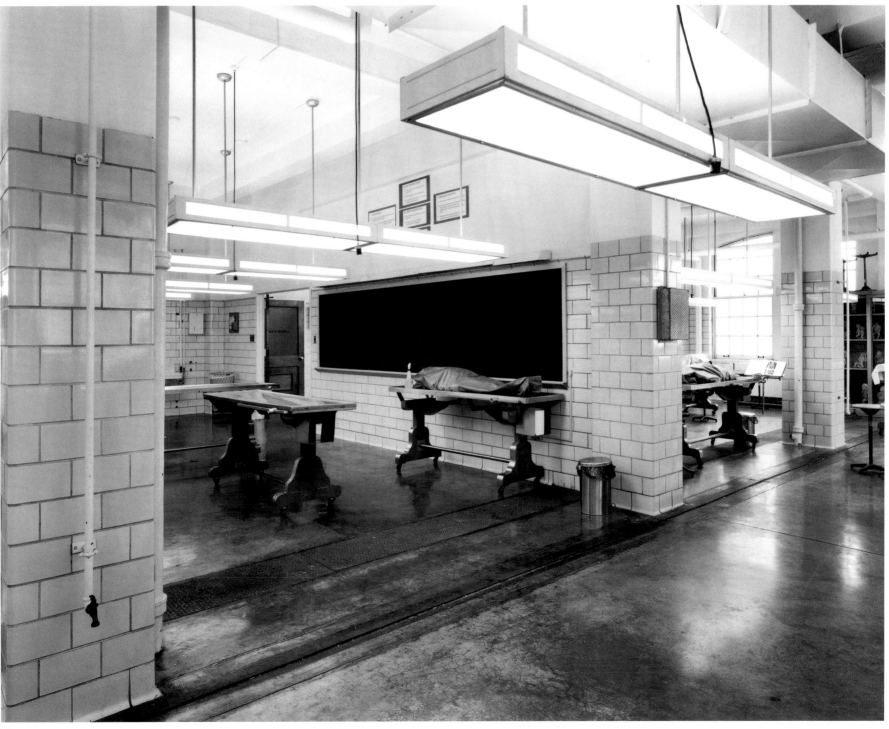

Classroom

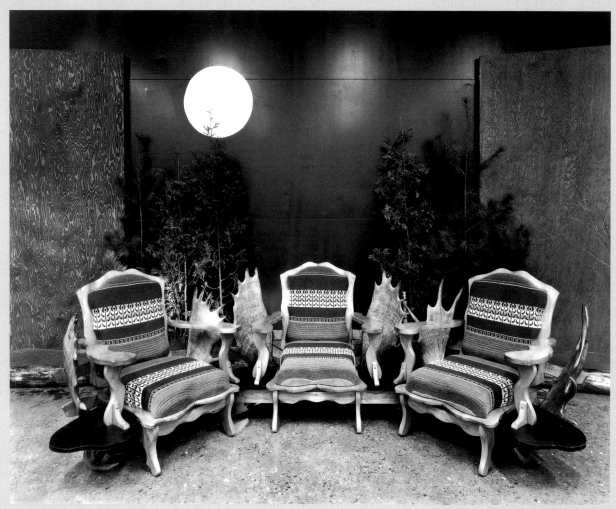

Exhibition Hall

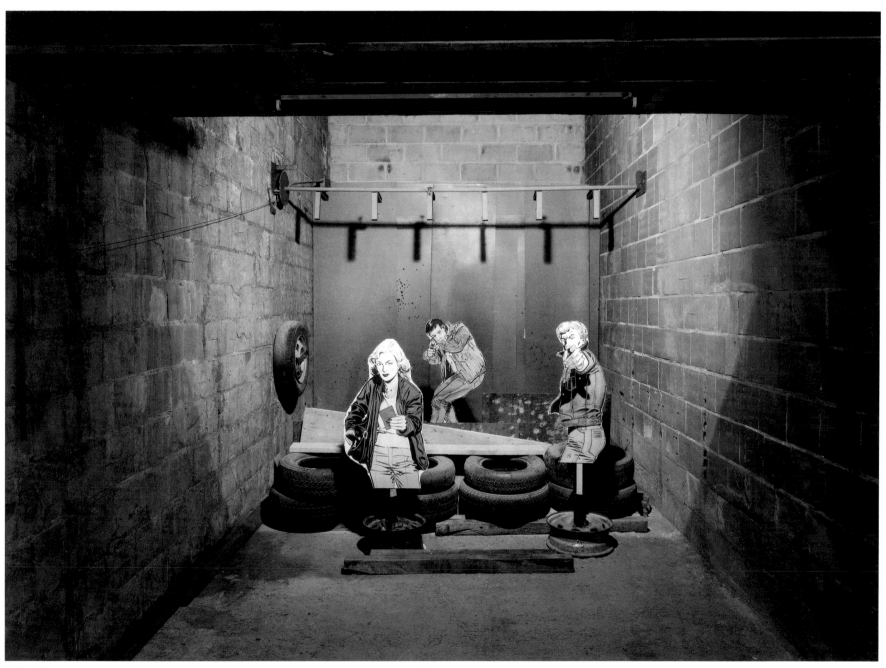

Police Range

Signs of Life

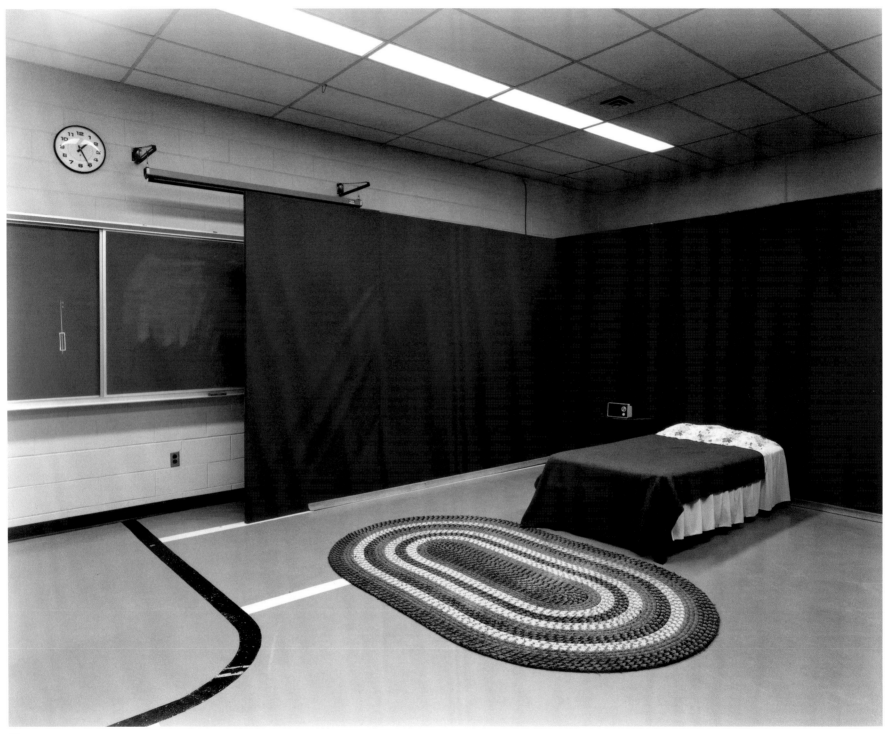

Classroom

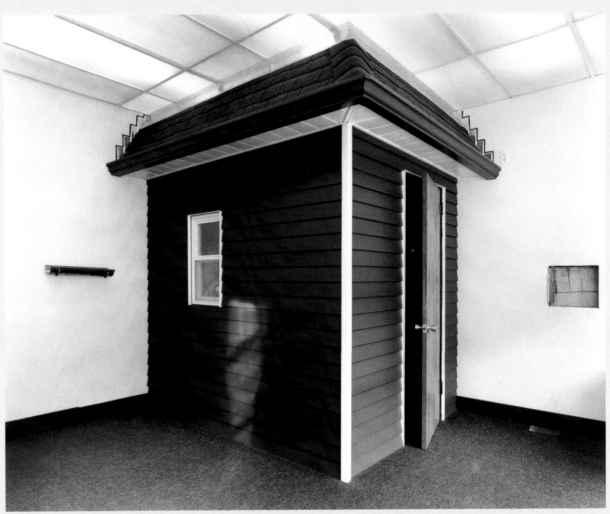

Office and Showroom

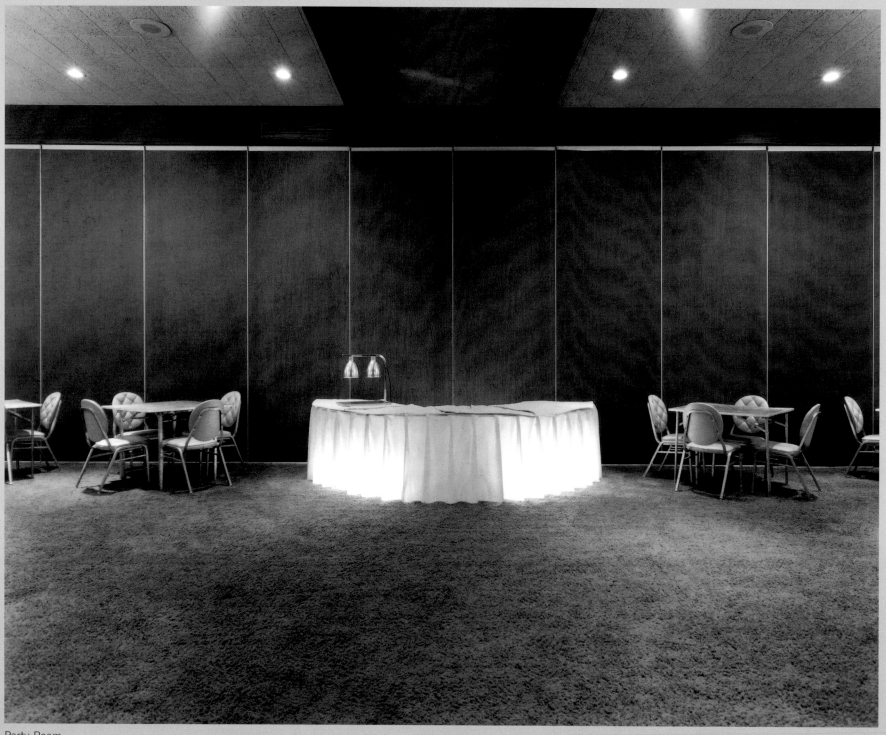

Party Room

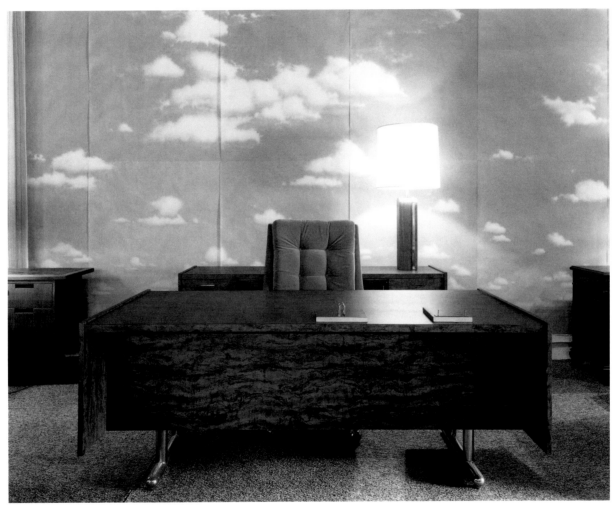

Corporate Office

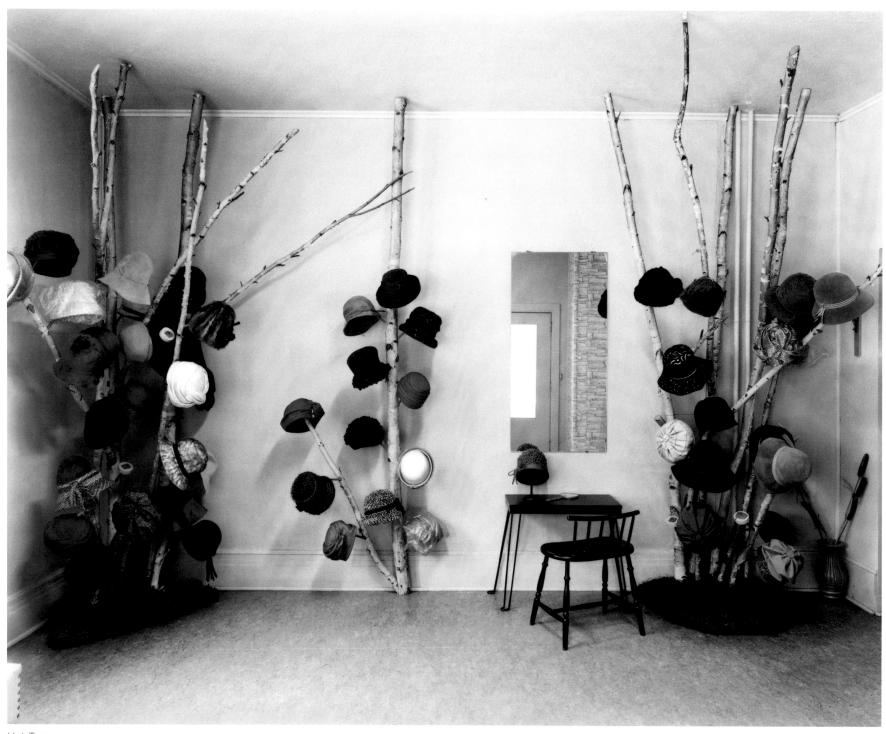

Hat Trees

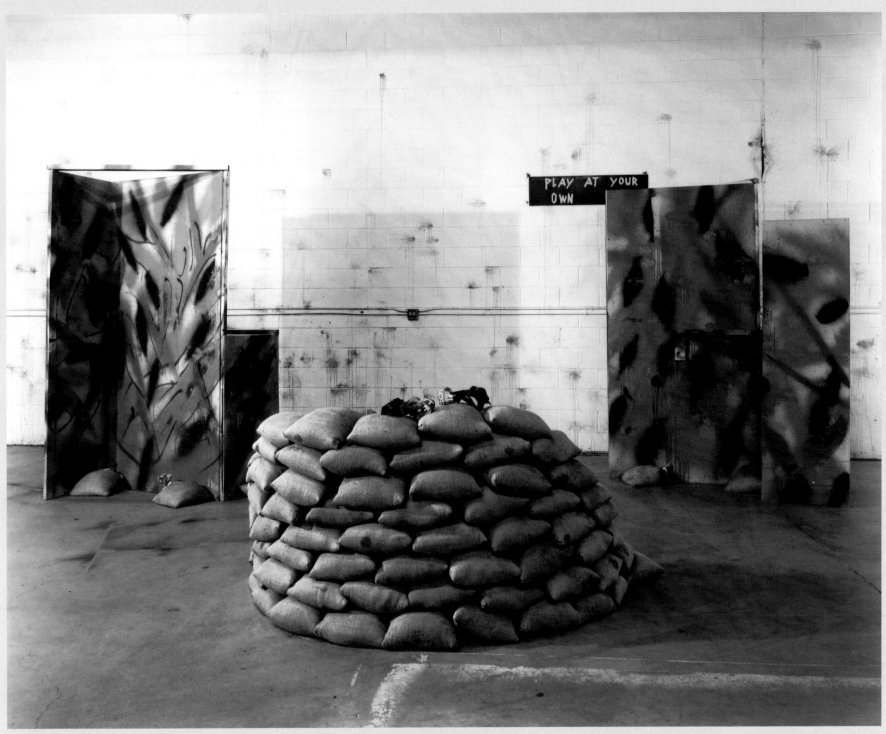

War Game

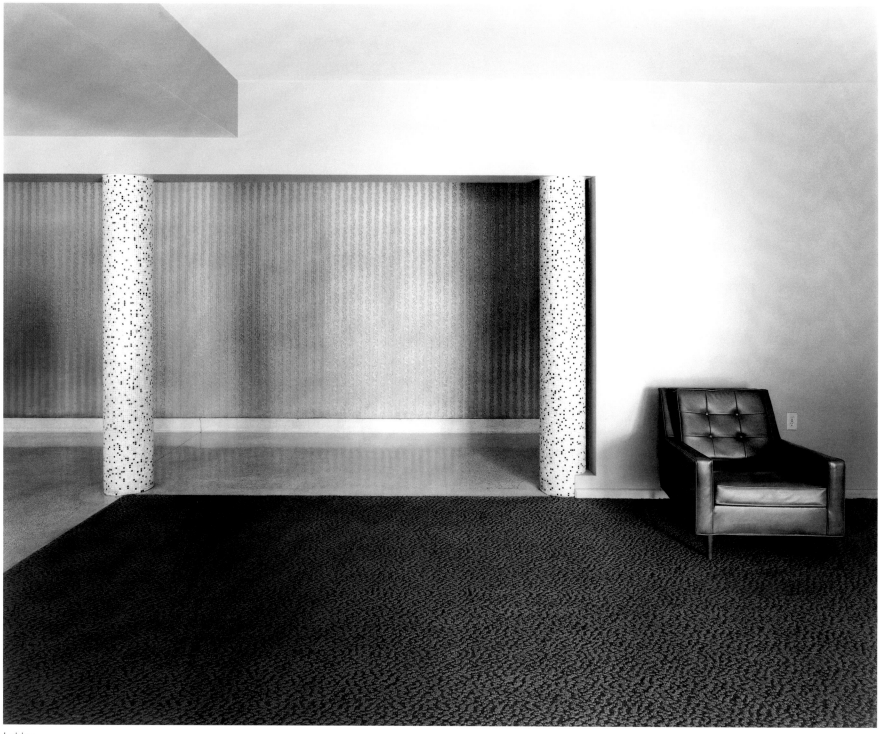

Lobby

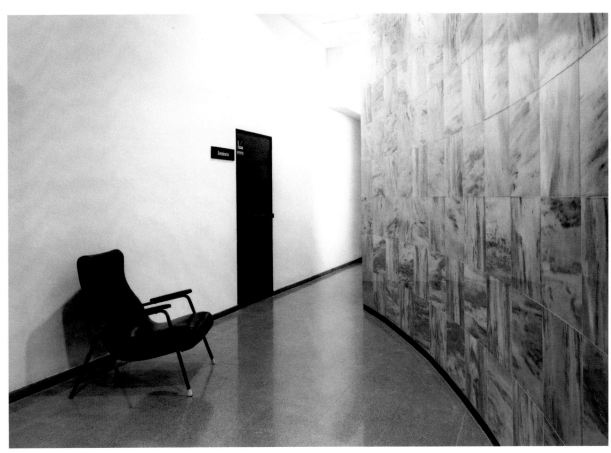

Corridor

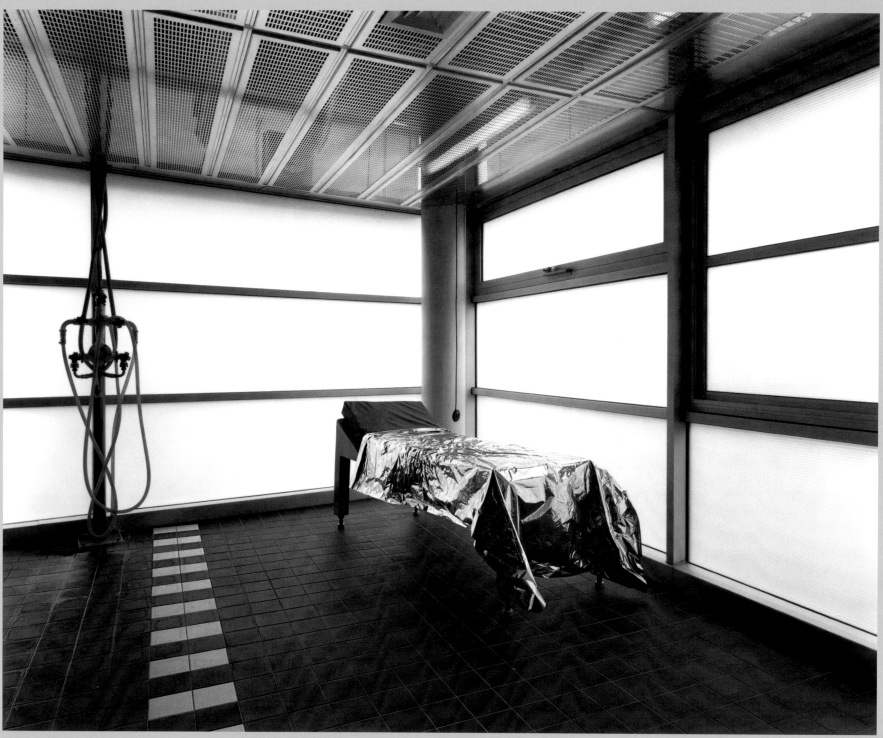

Spa

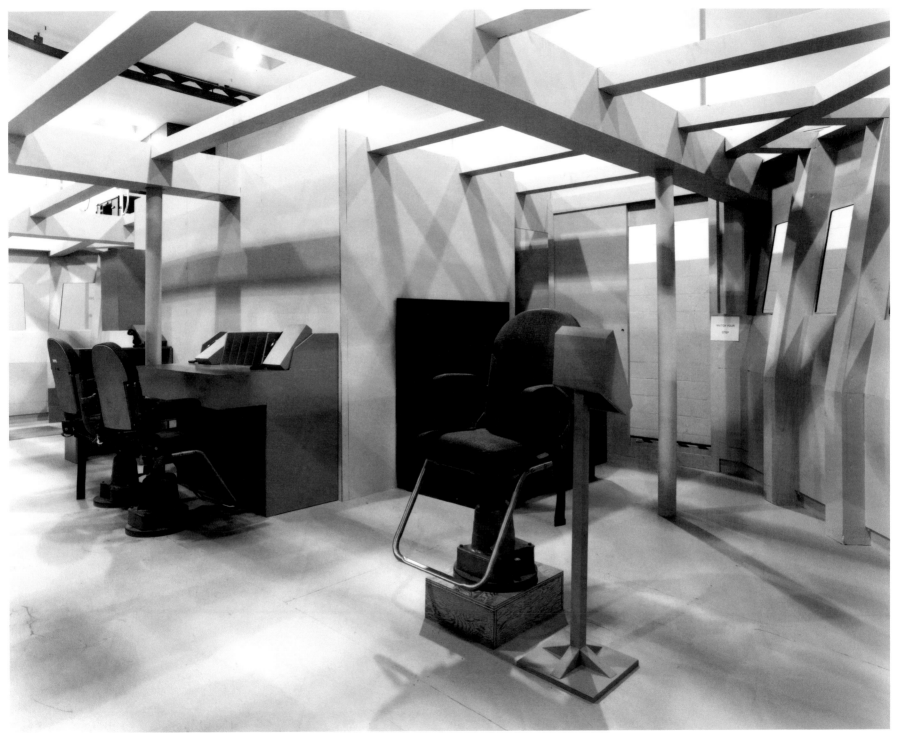

Classroom

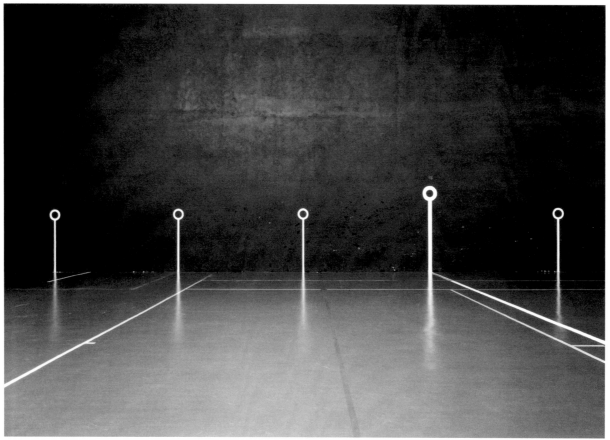

Classroom

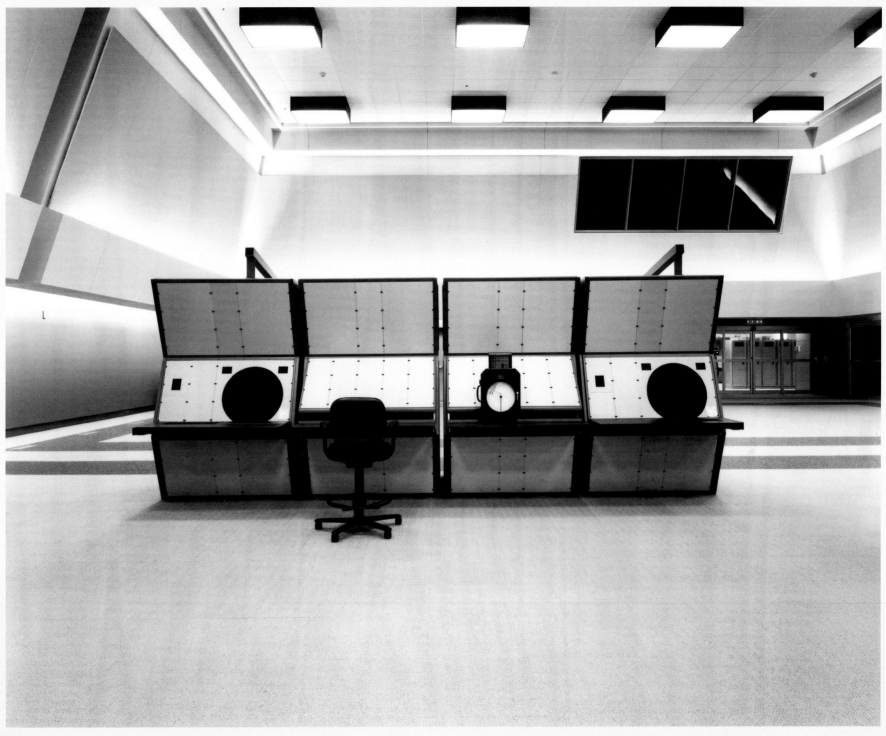

Classroom

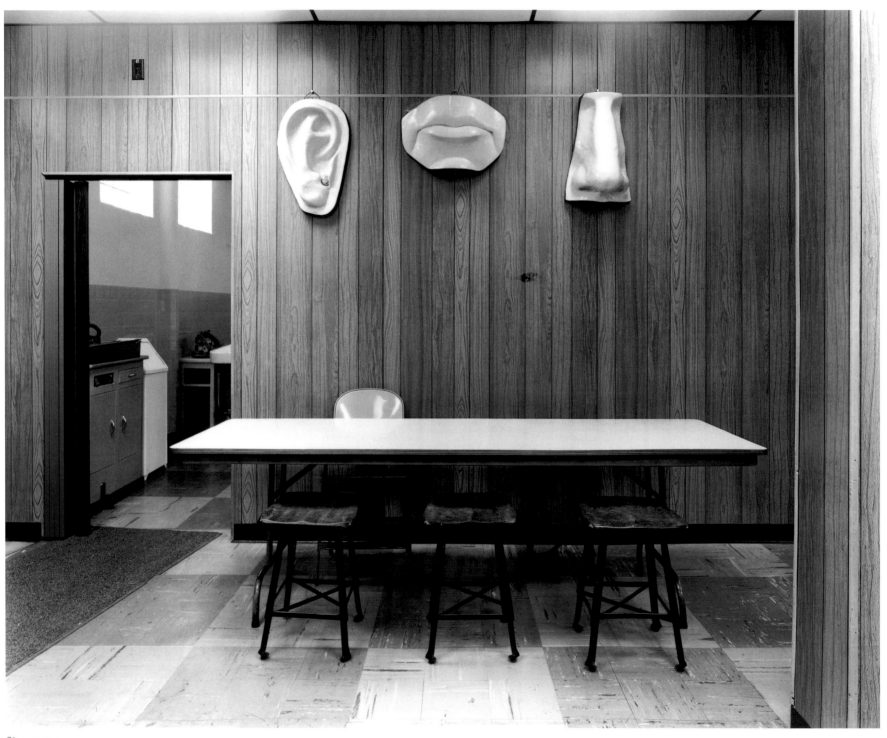

Classroom

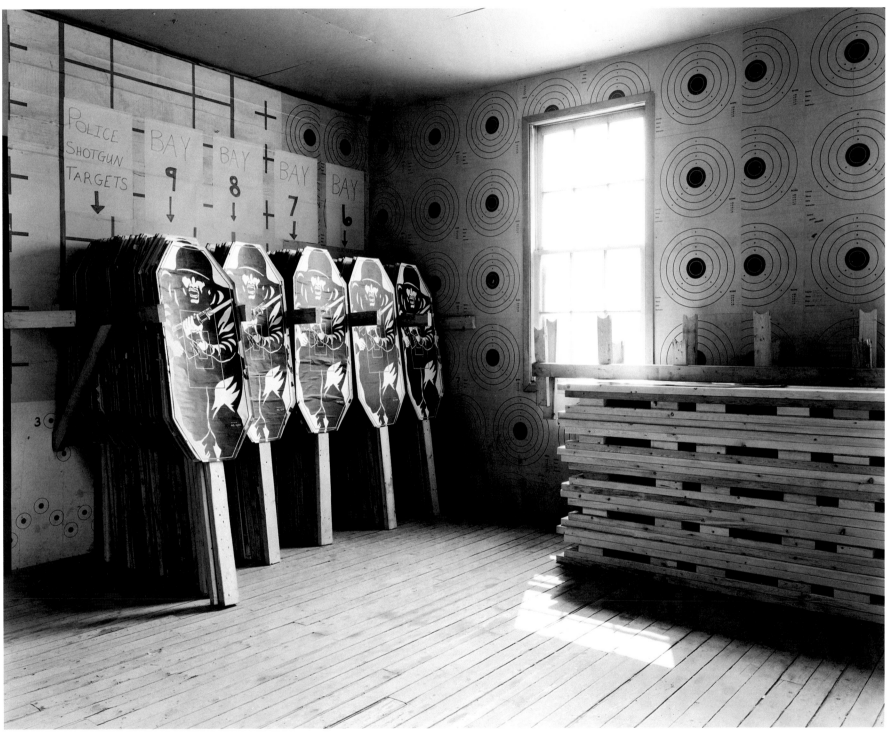

Military Installation

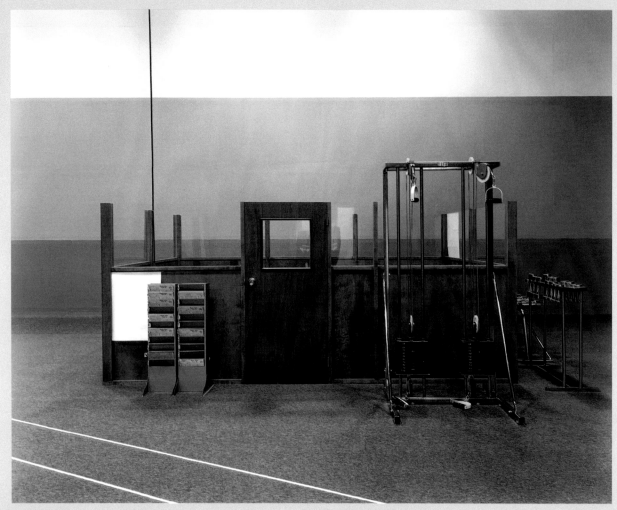

Racquet Club

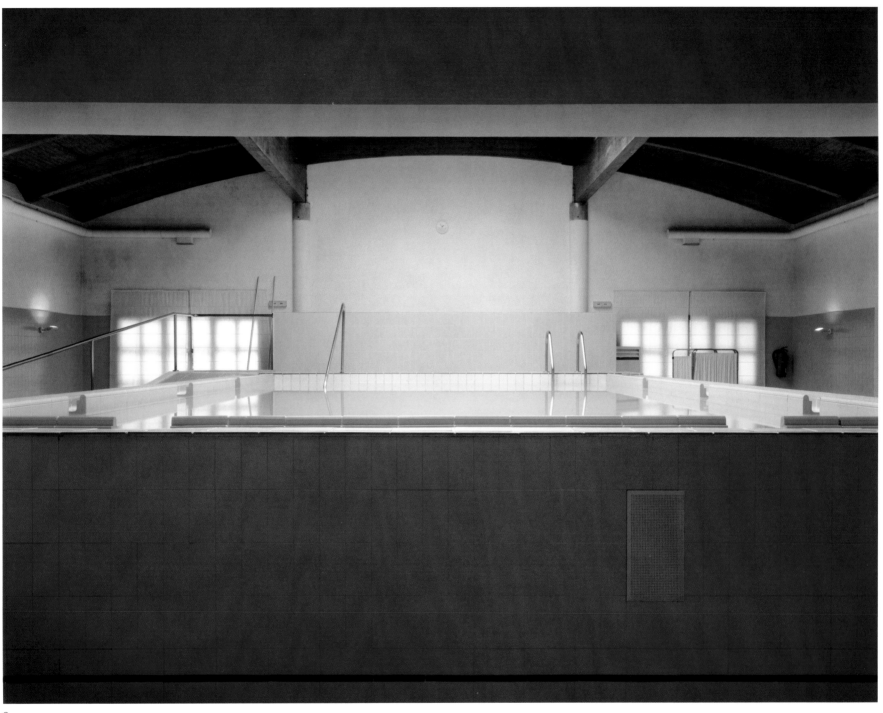

Spa

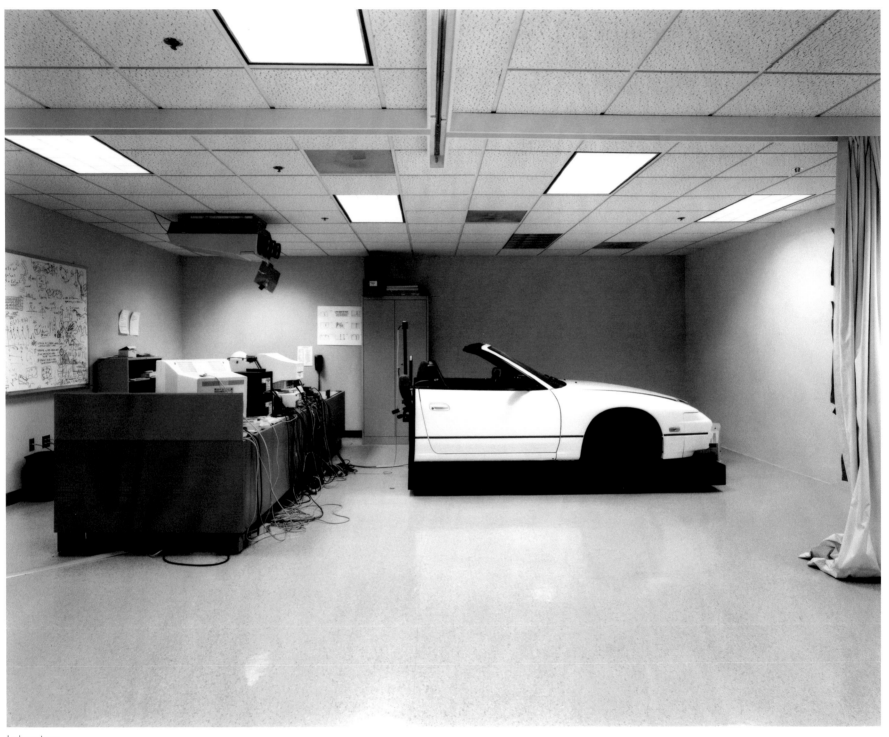

Laboratory

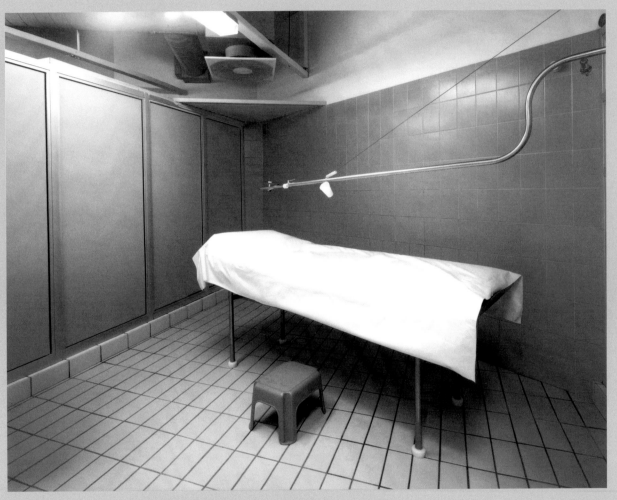

Spa

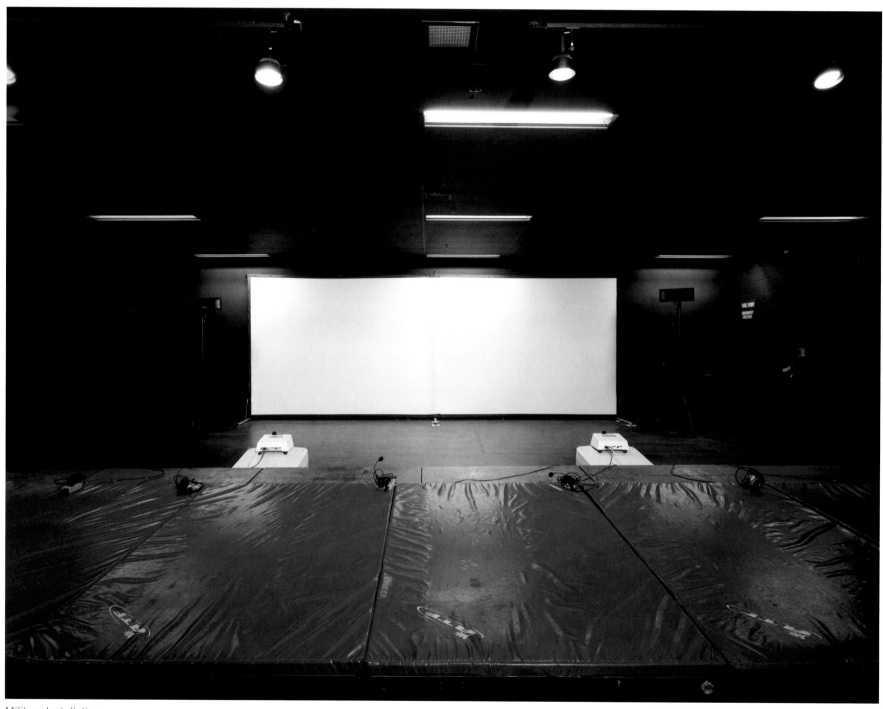

Military Installation

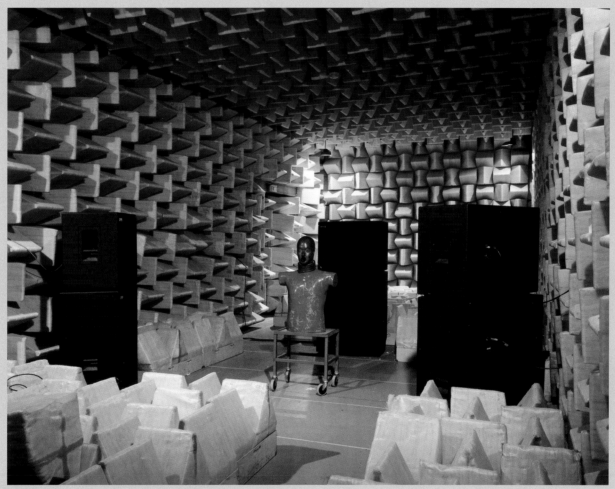

Laboratory

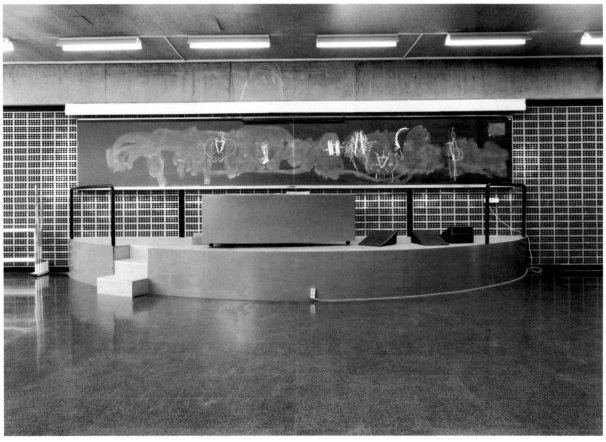

Classroom

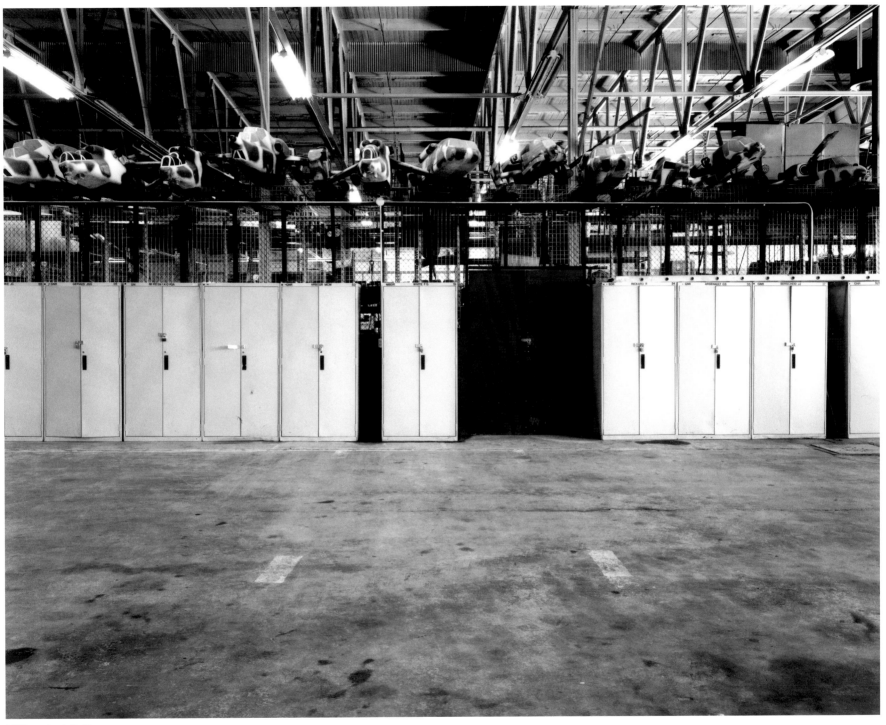

Military Installation

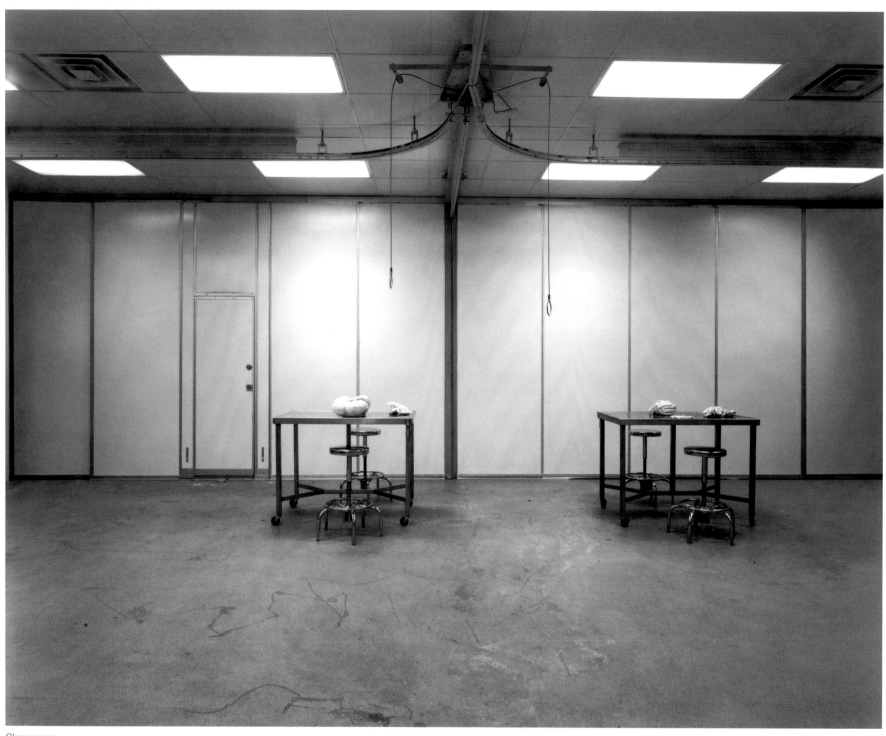

Classroom

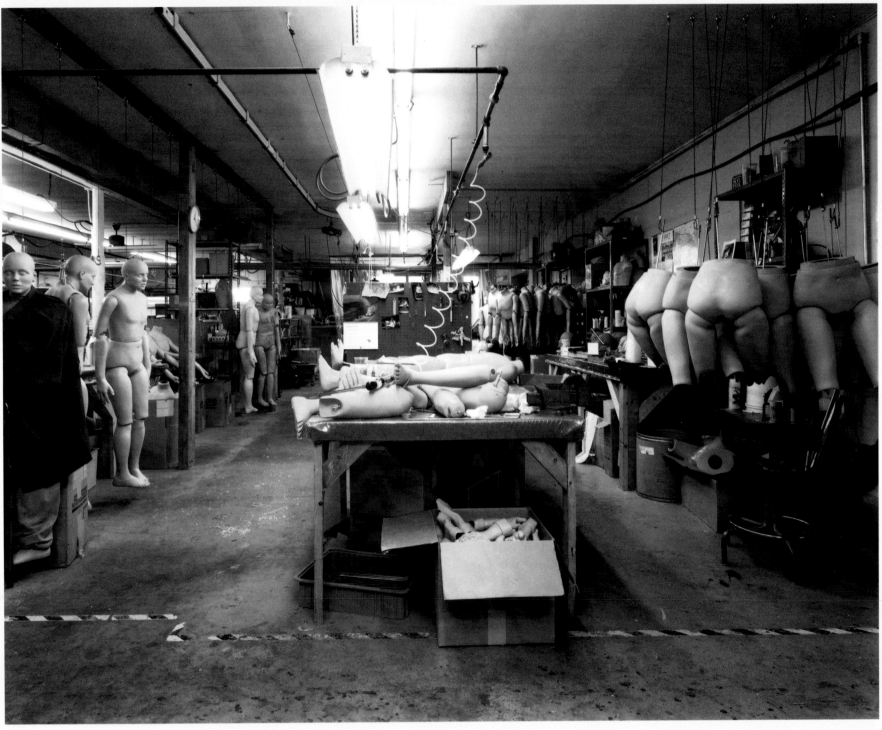

Factory

Smoke & Mirrors

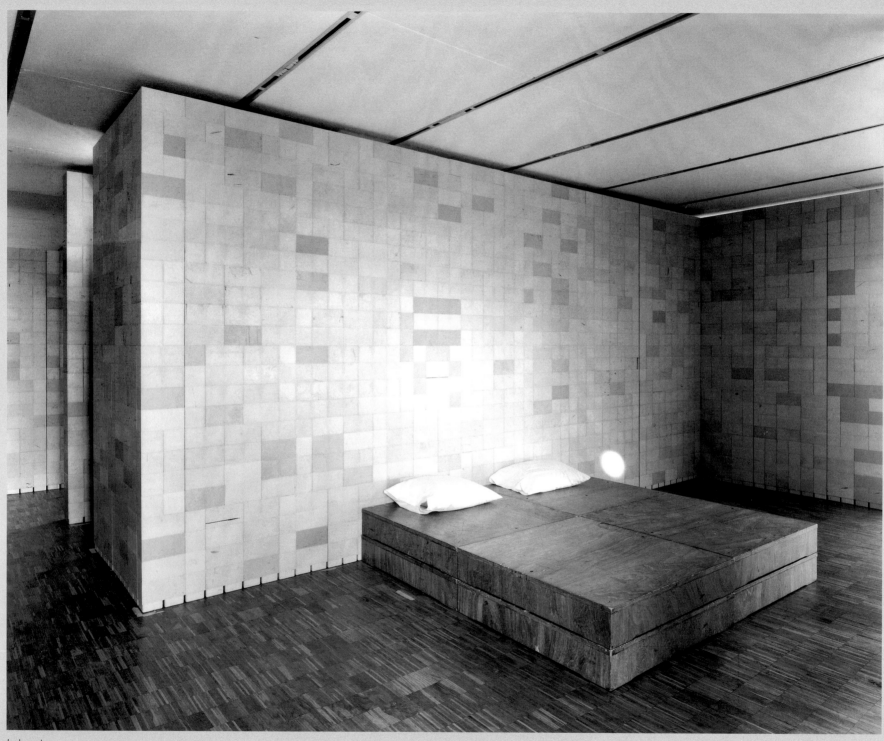

Laboratory

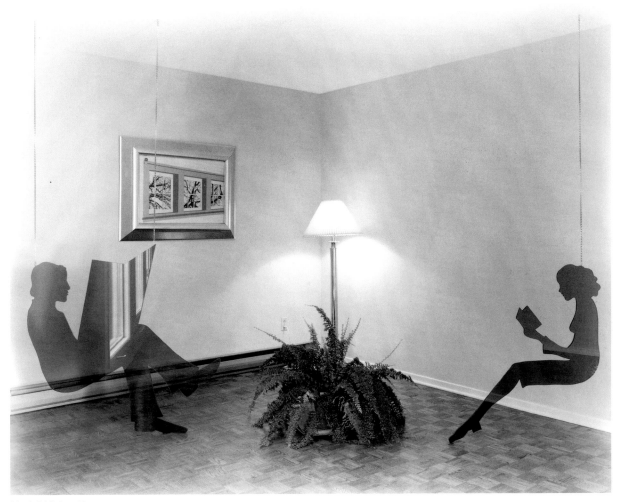

Model Living Room

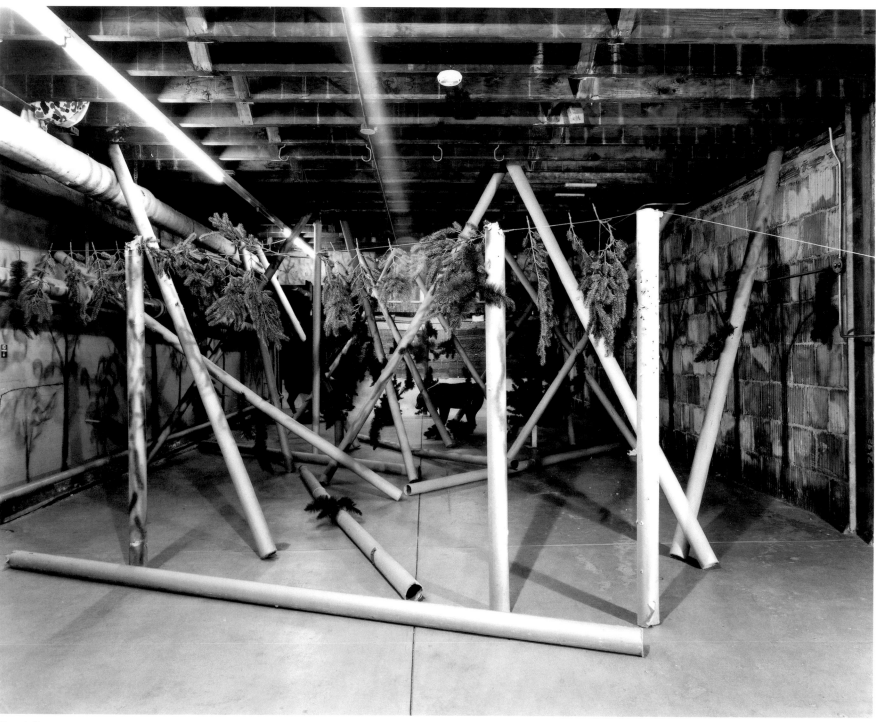

Target Range

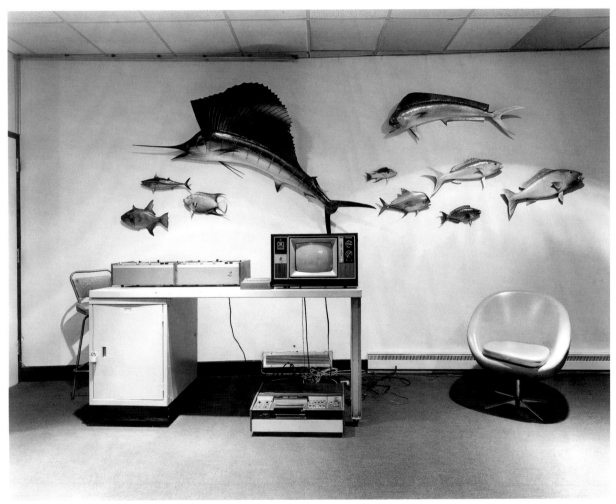

Recording Studio

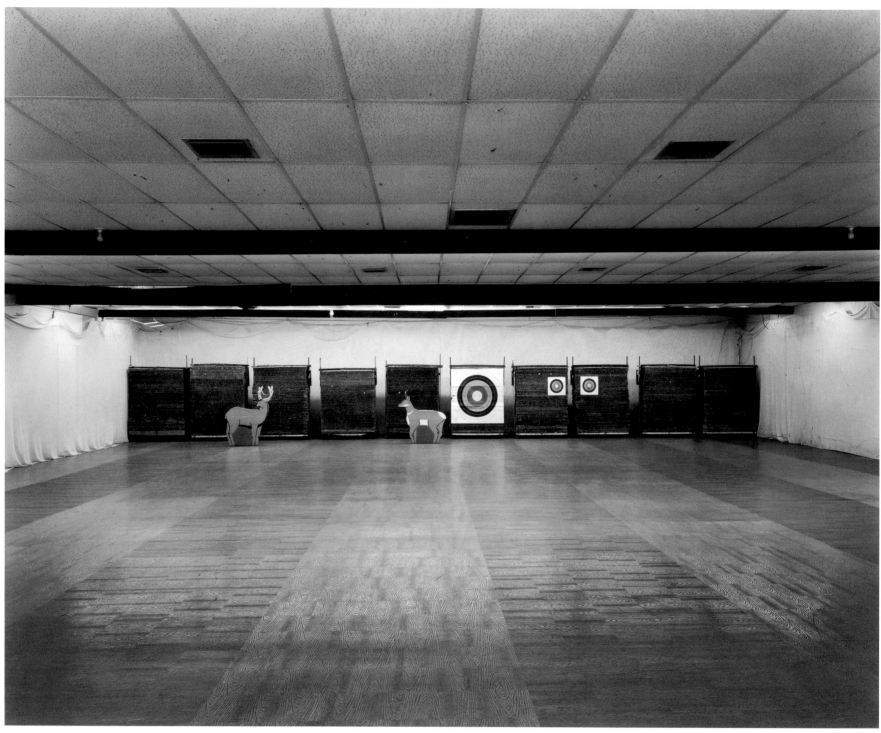

Target Range

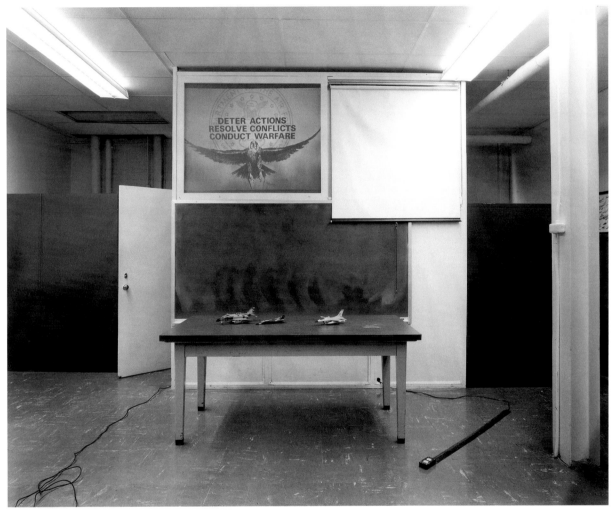

Classroom

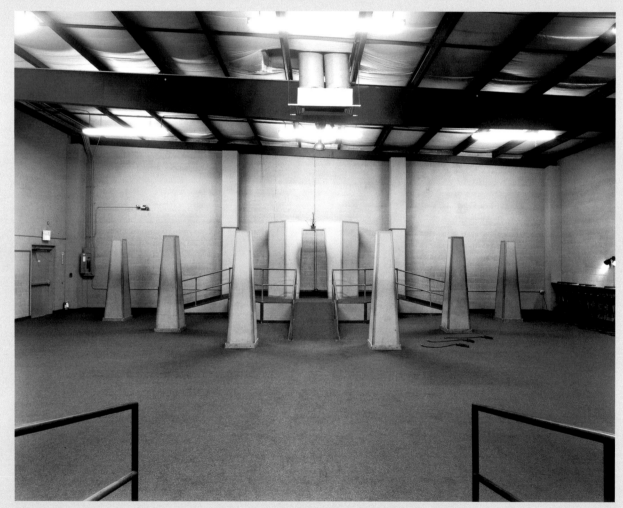

War Game

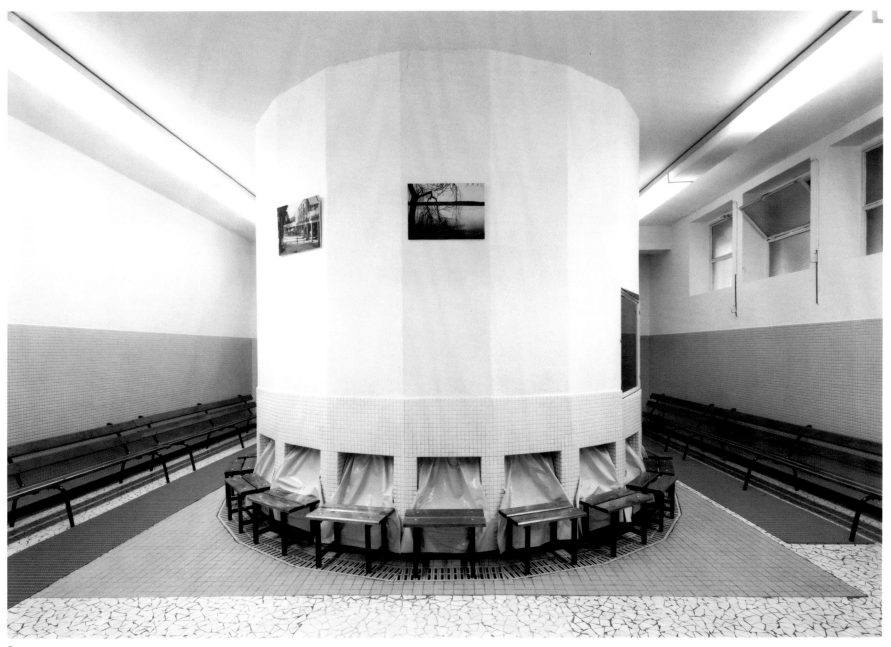

Spa

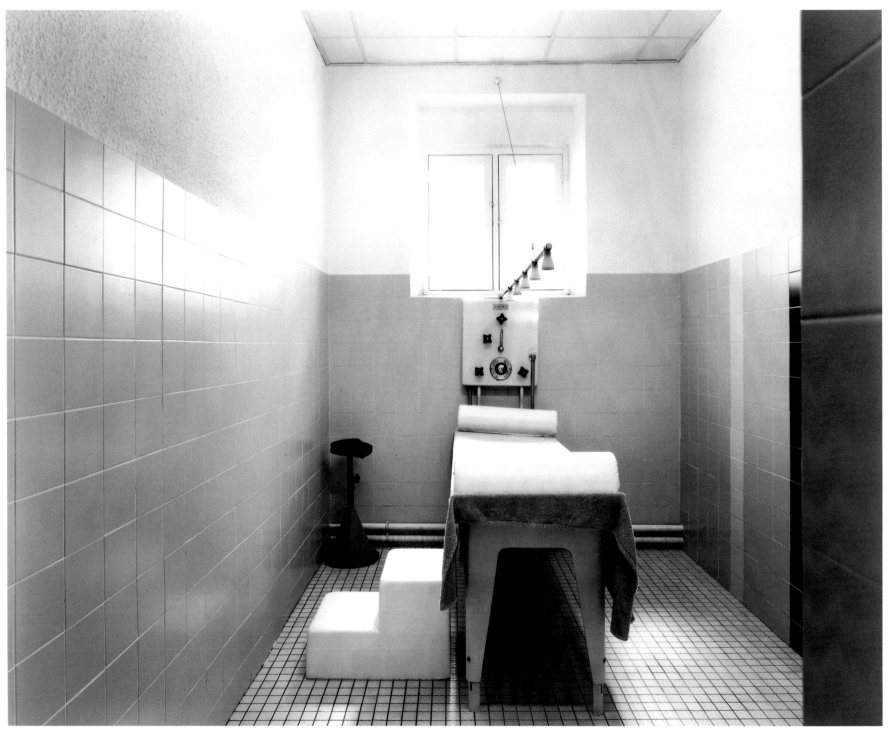

Spa

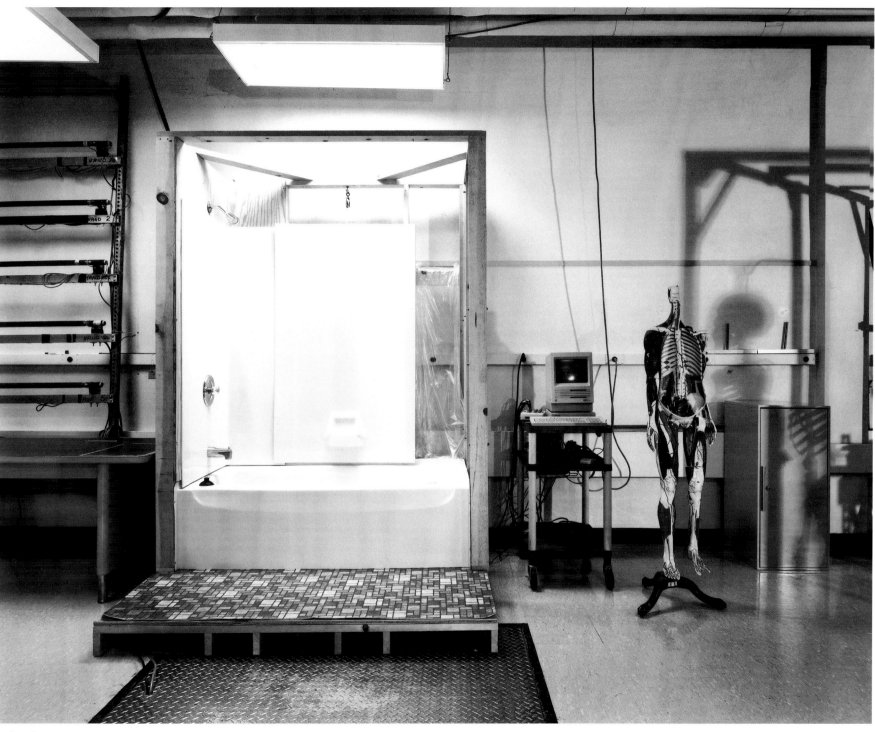

Laboratory

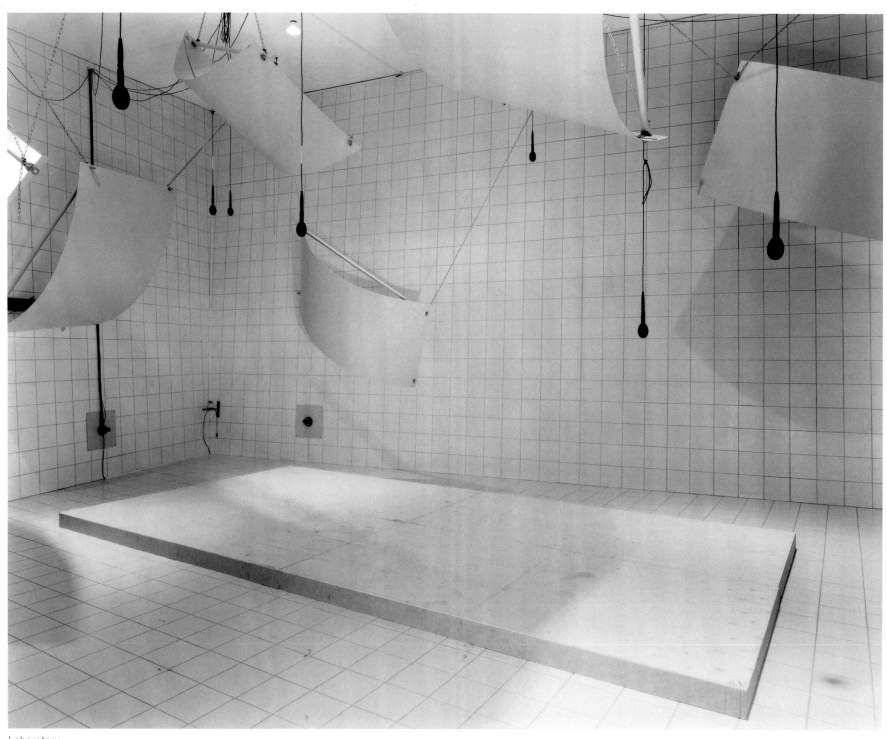

Laboratory

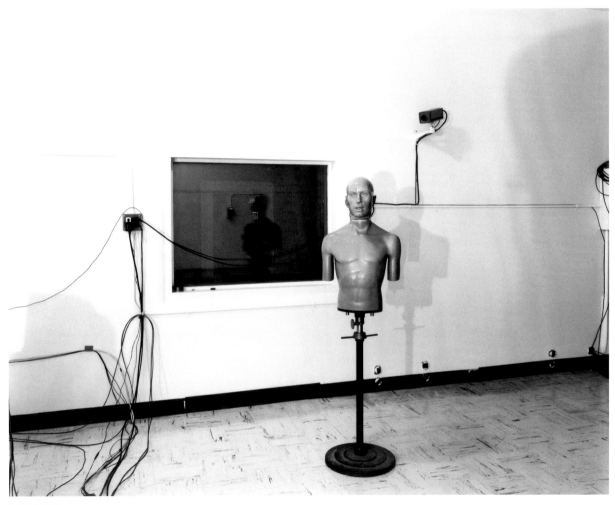

Laboratory

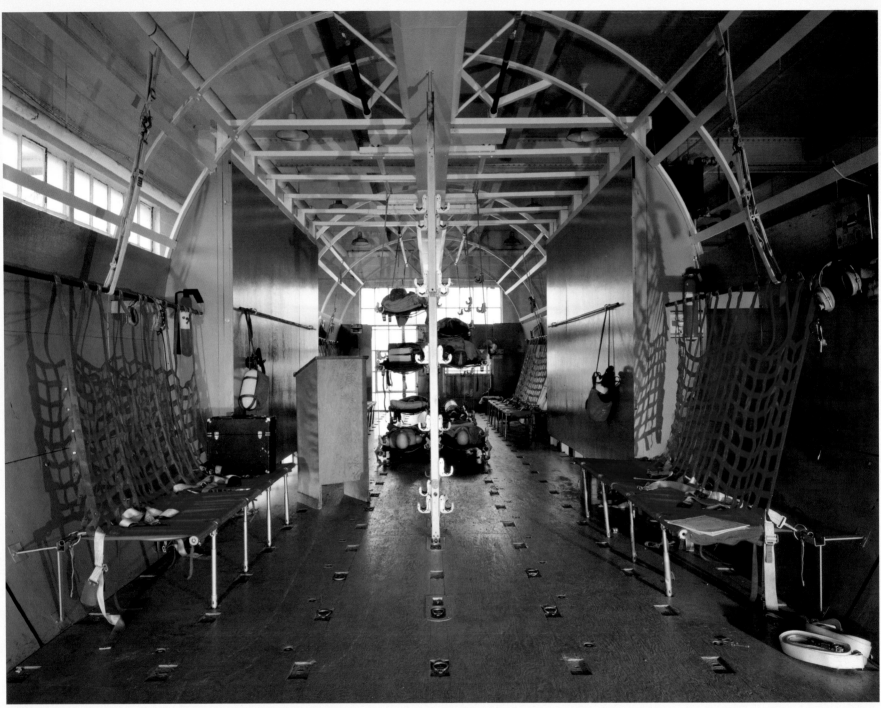

Military Installation

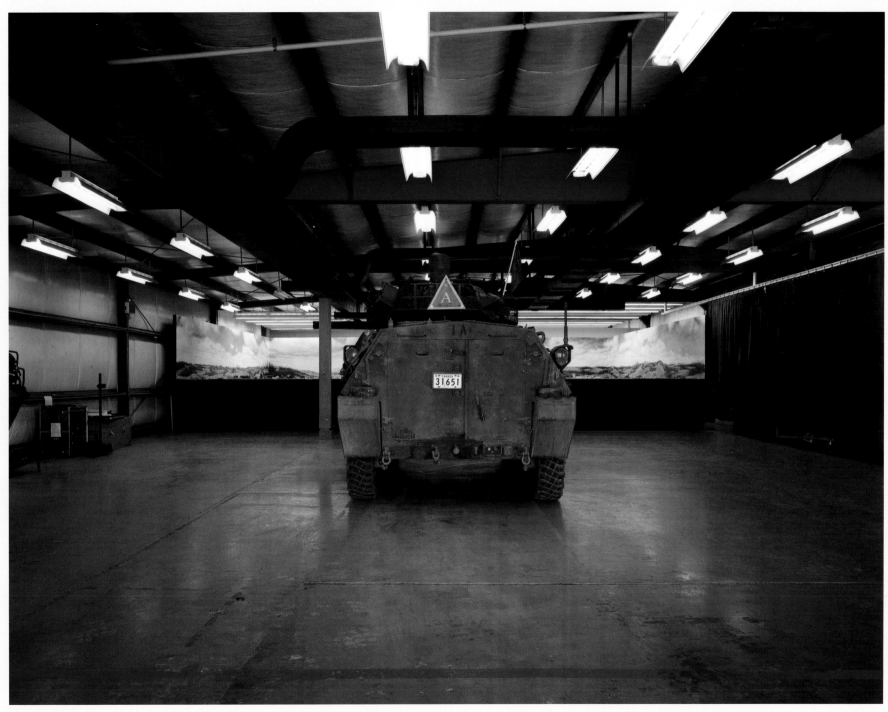

Military Installation

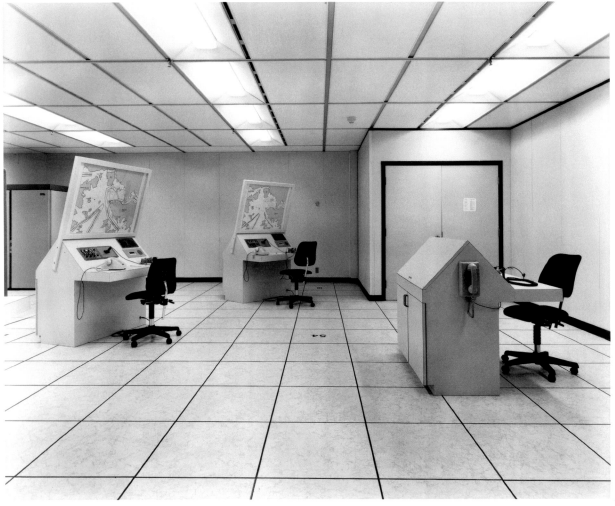

Classroom

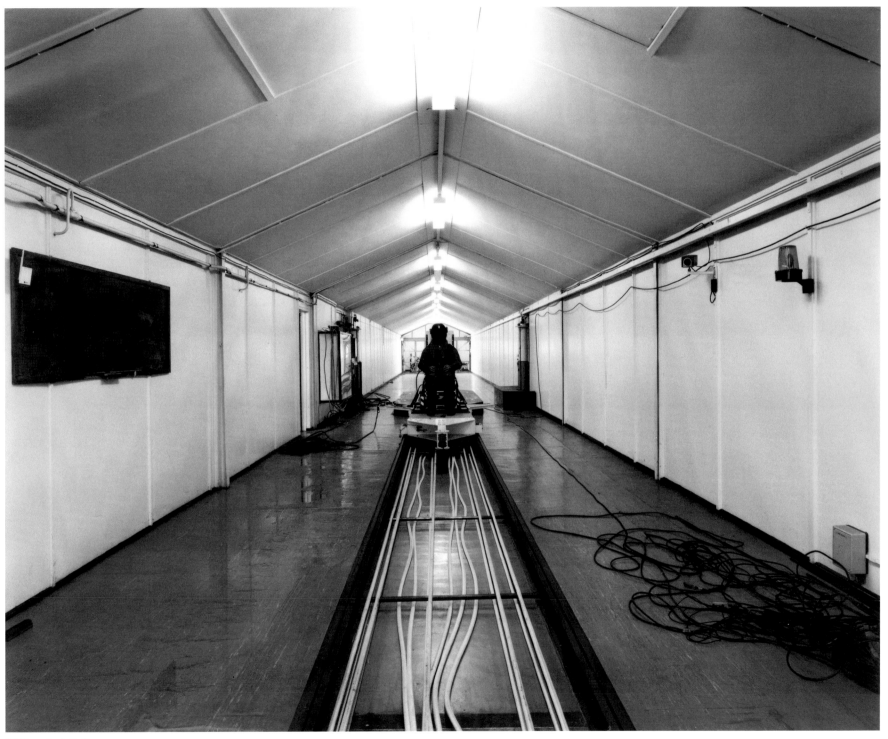

Military Installation

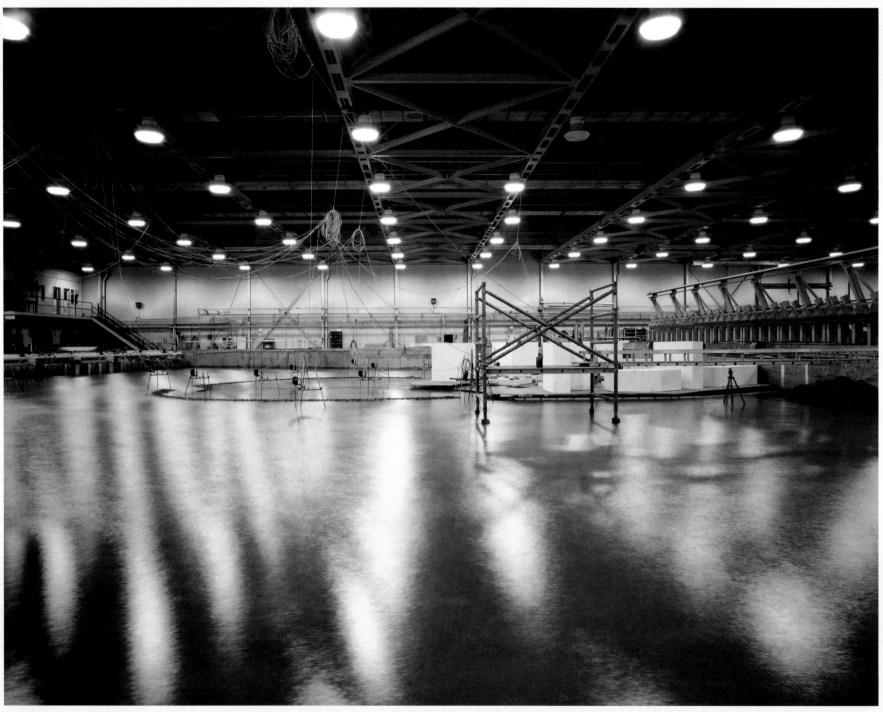

Laboratory

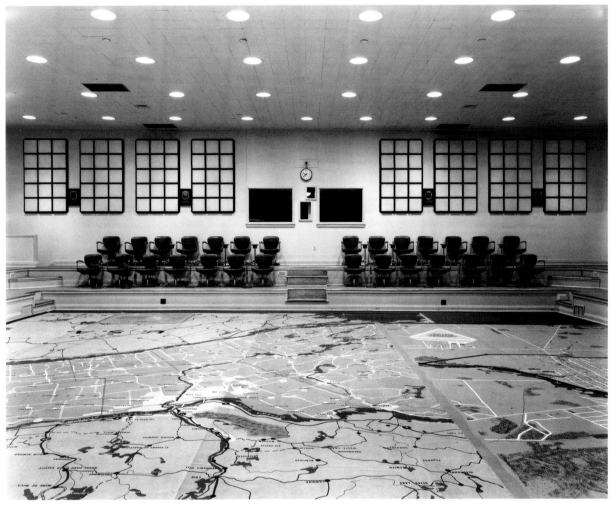

Hall

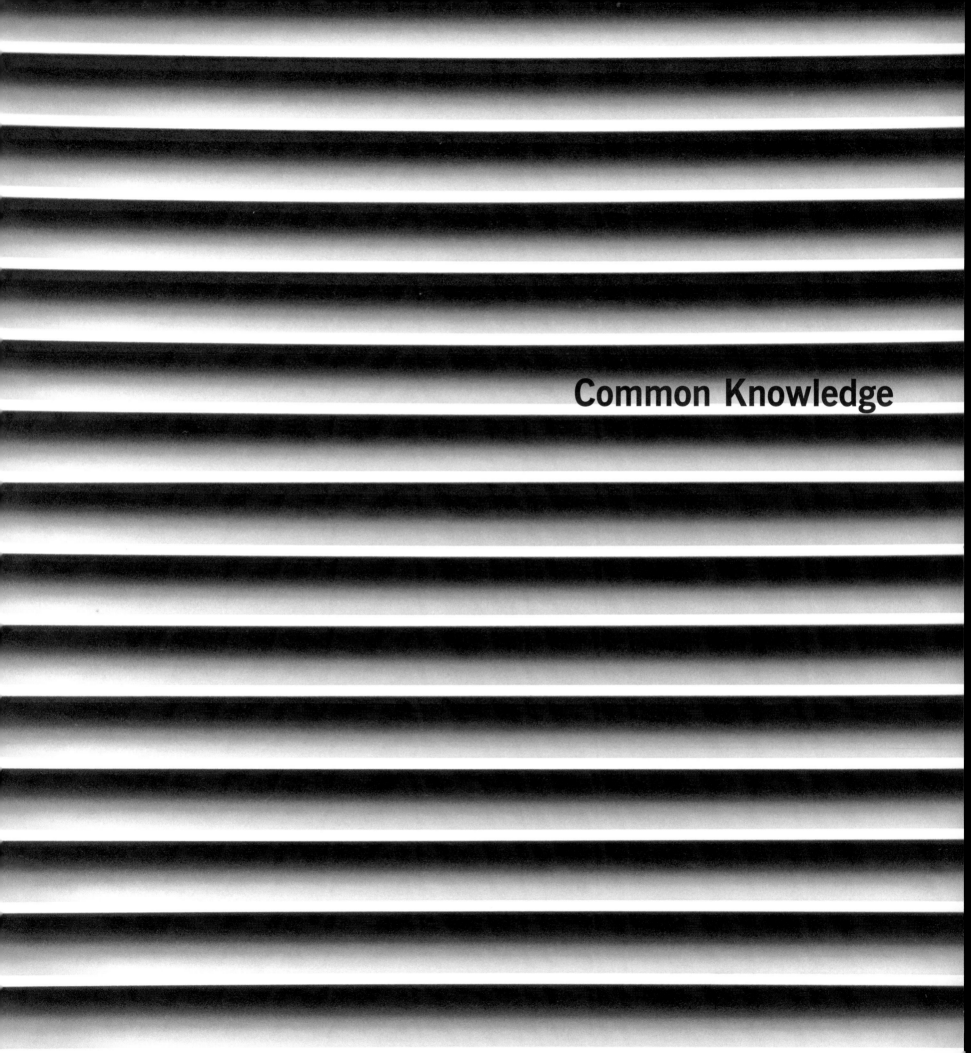

Common Knowledge

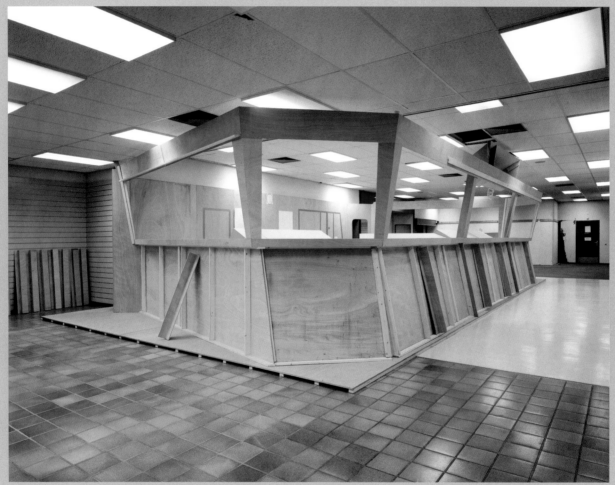

Military Installation

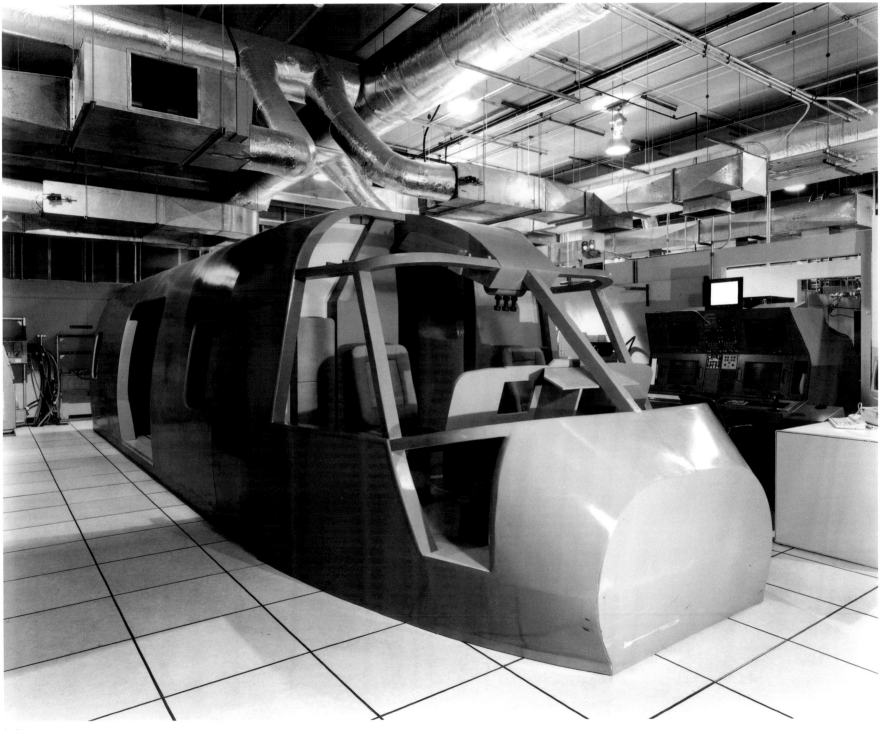

Laboratory

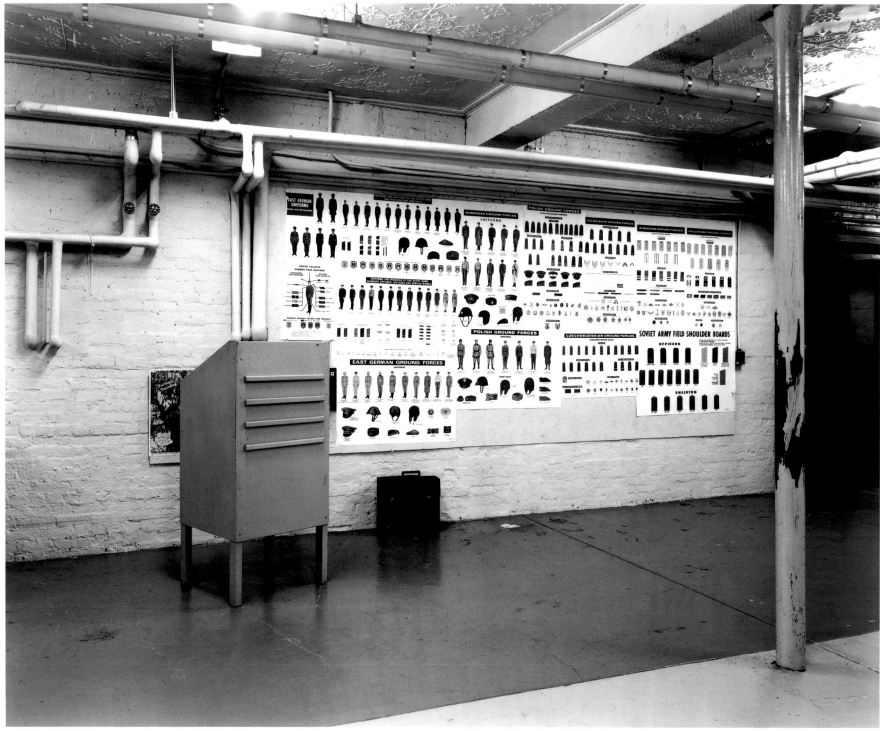

Classroom

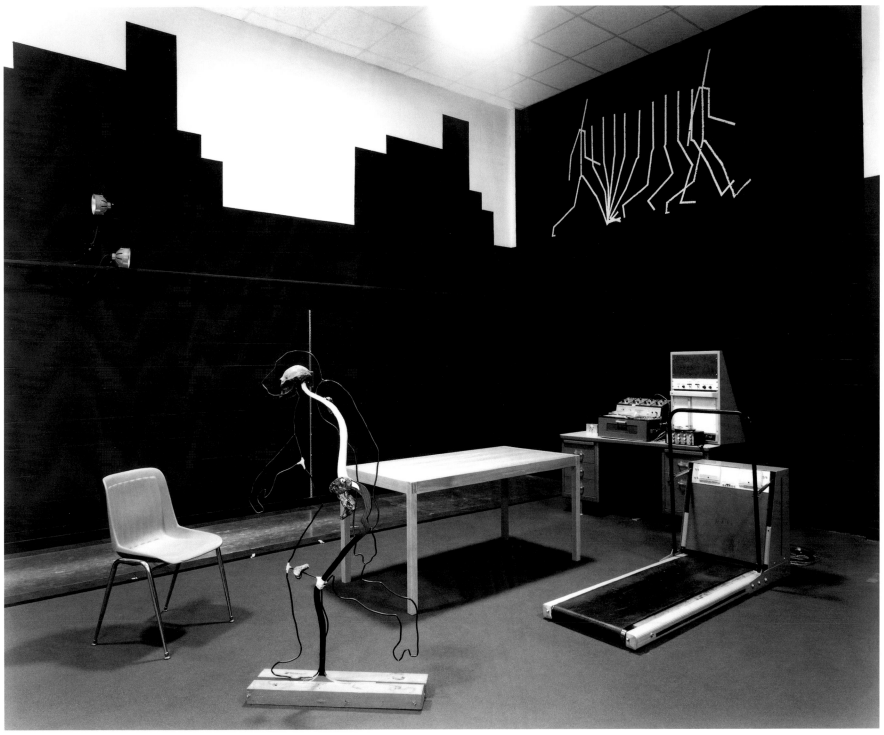

Classroom

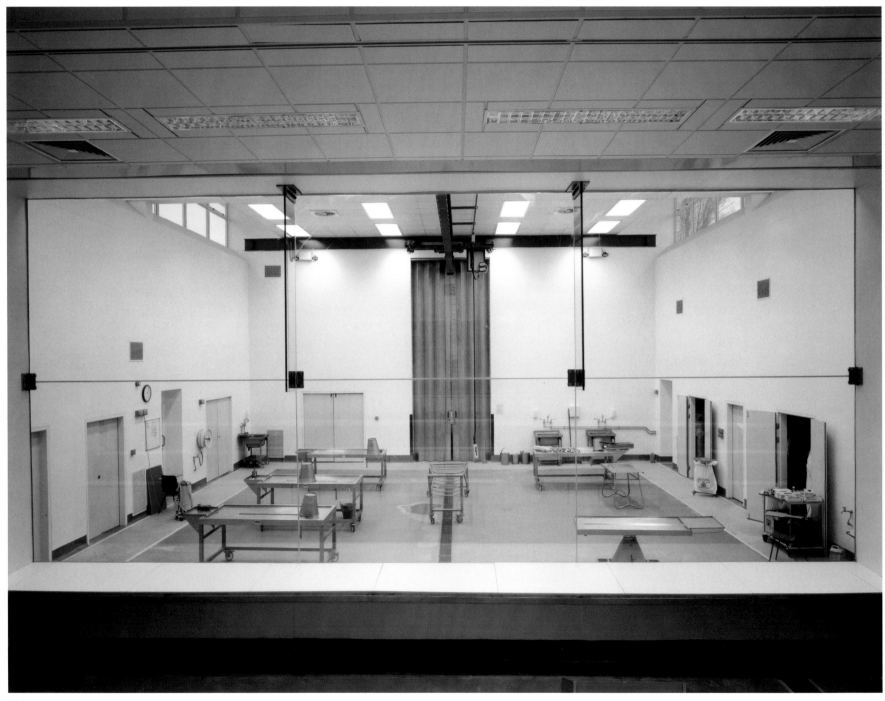

Laboratory

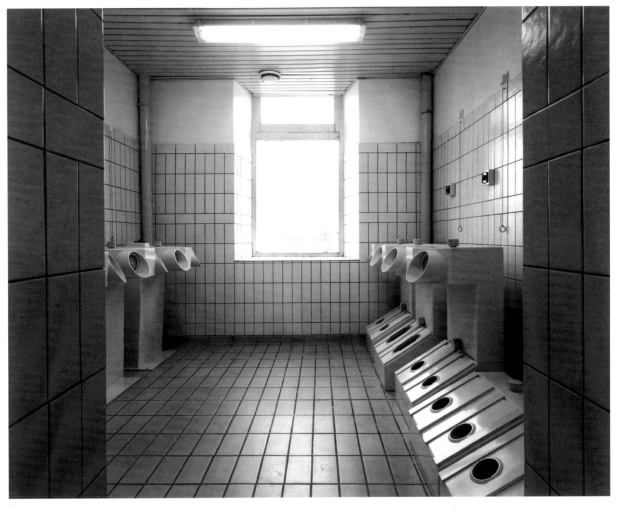

Spa

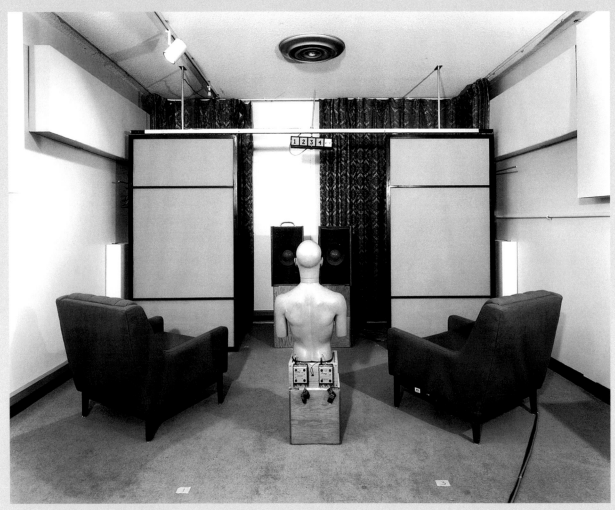

Laboratory

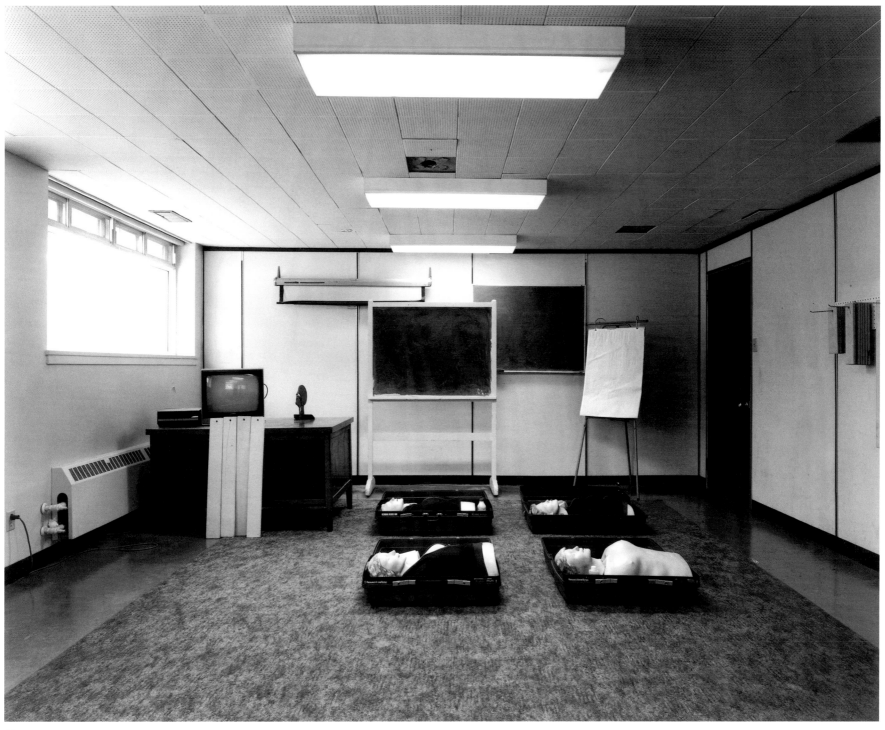

Classroom

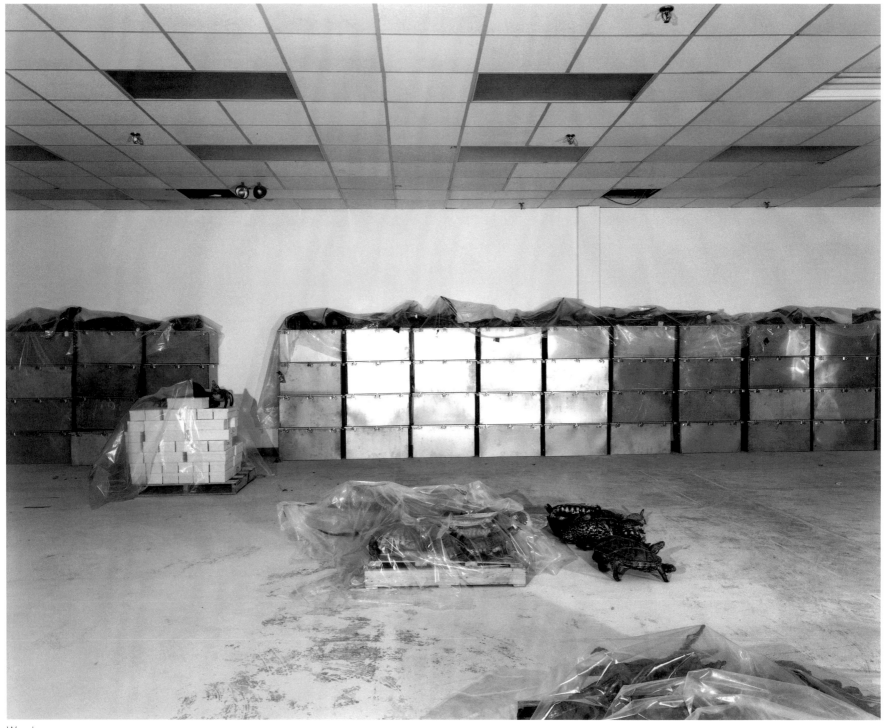

Warehouse

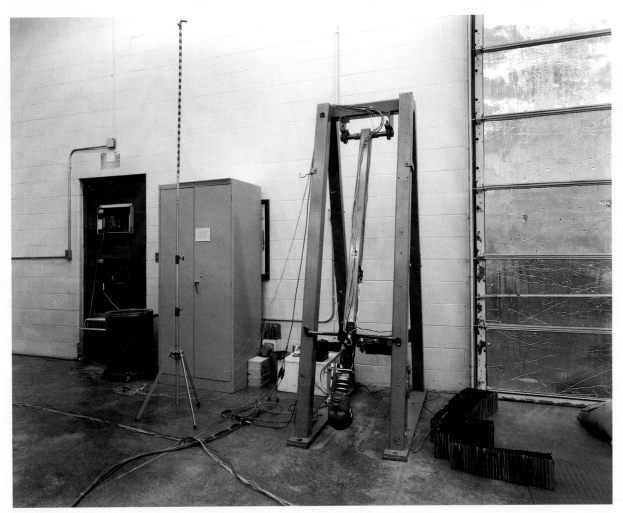

Laboratory

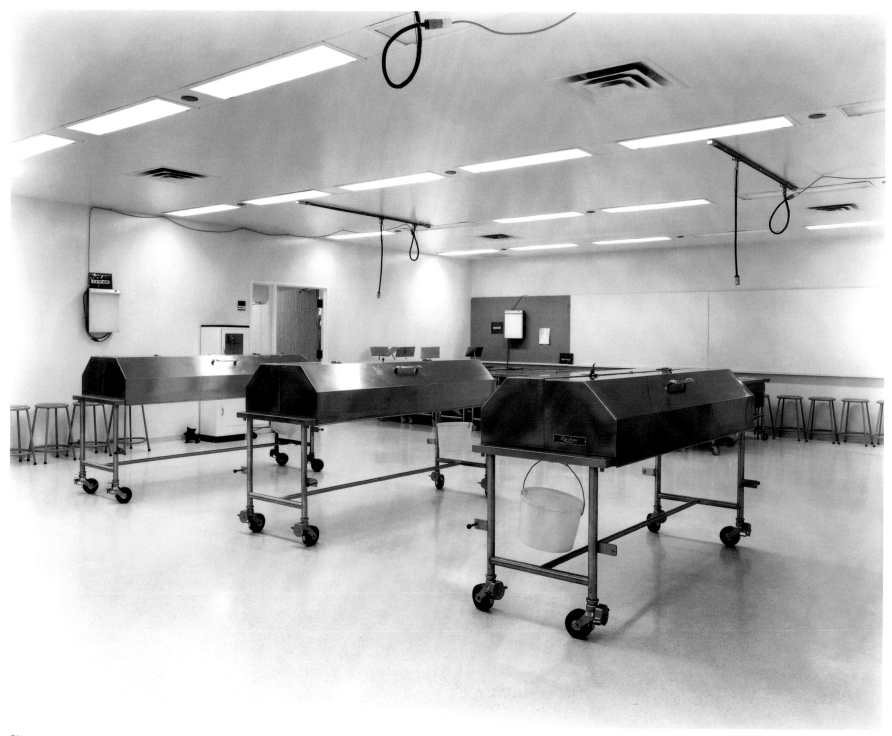

Classroom

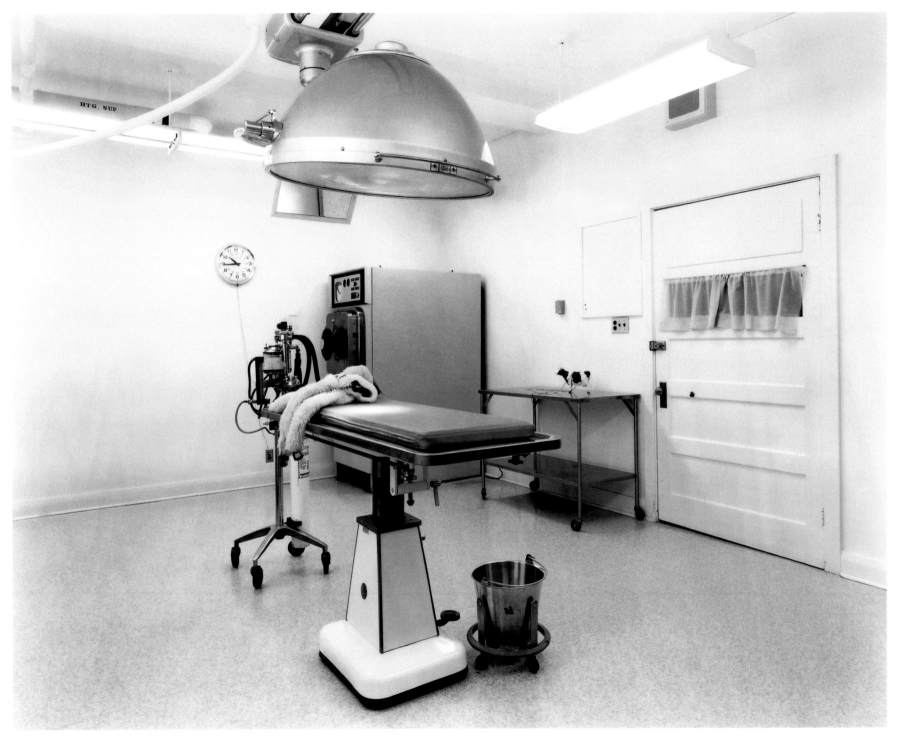

Classroom

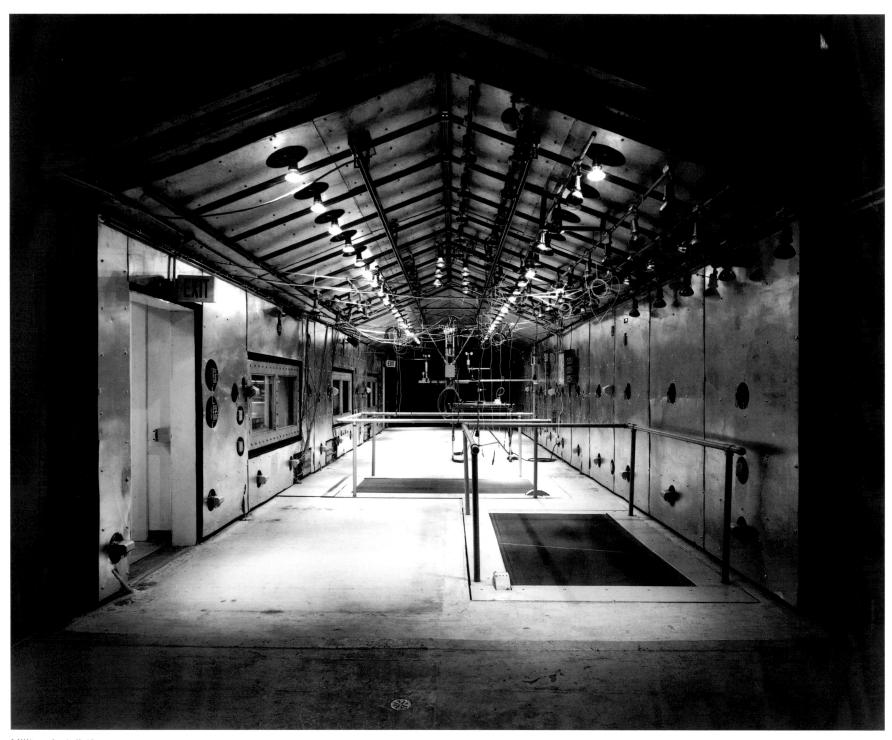

Military Installation

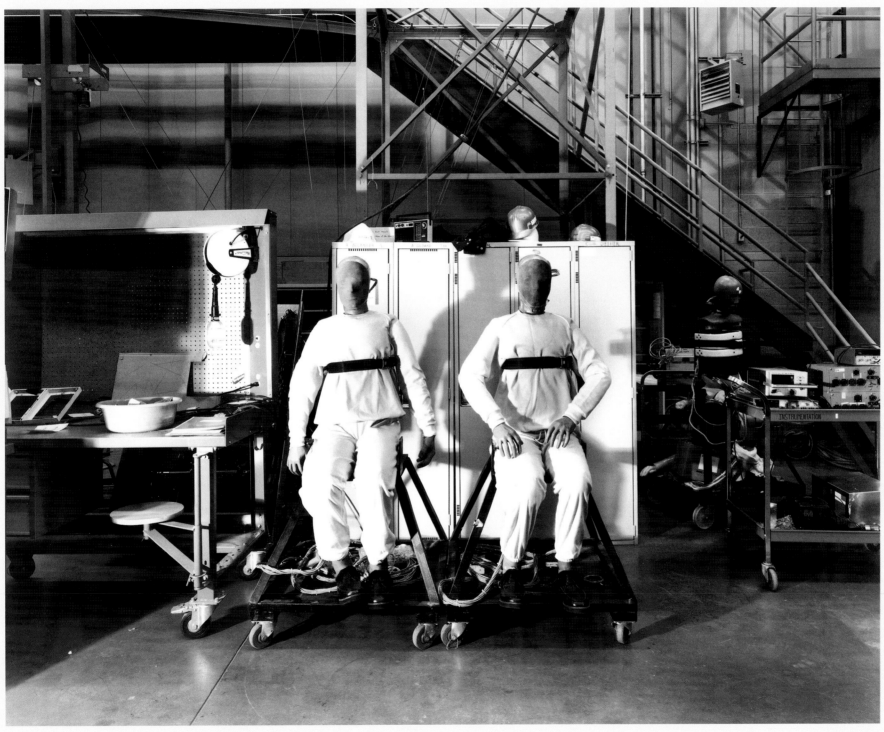

Laboratory

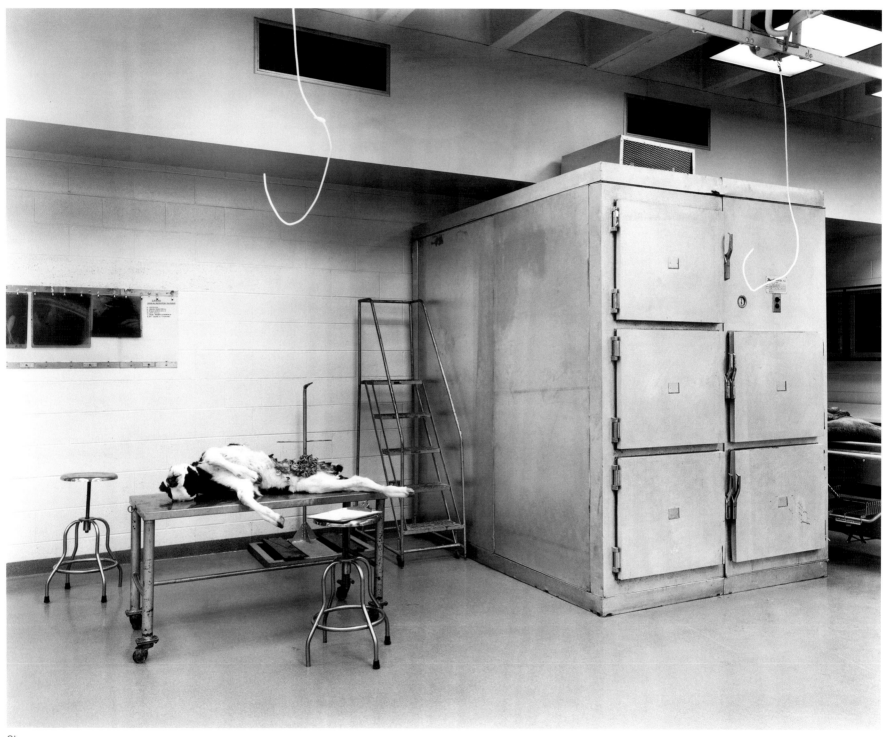

Classroom

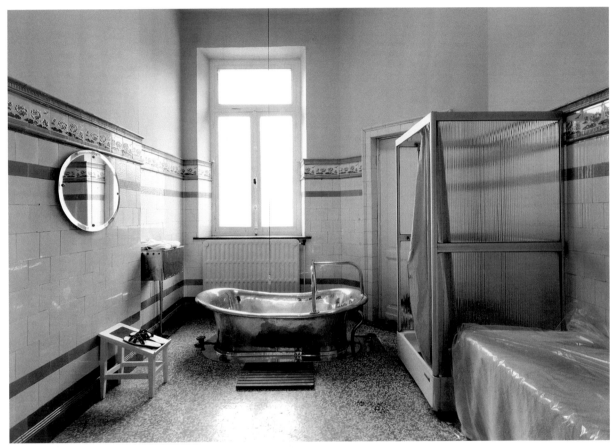

Spa

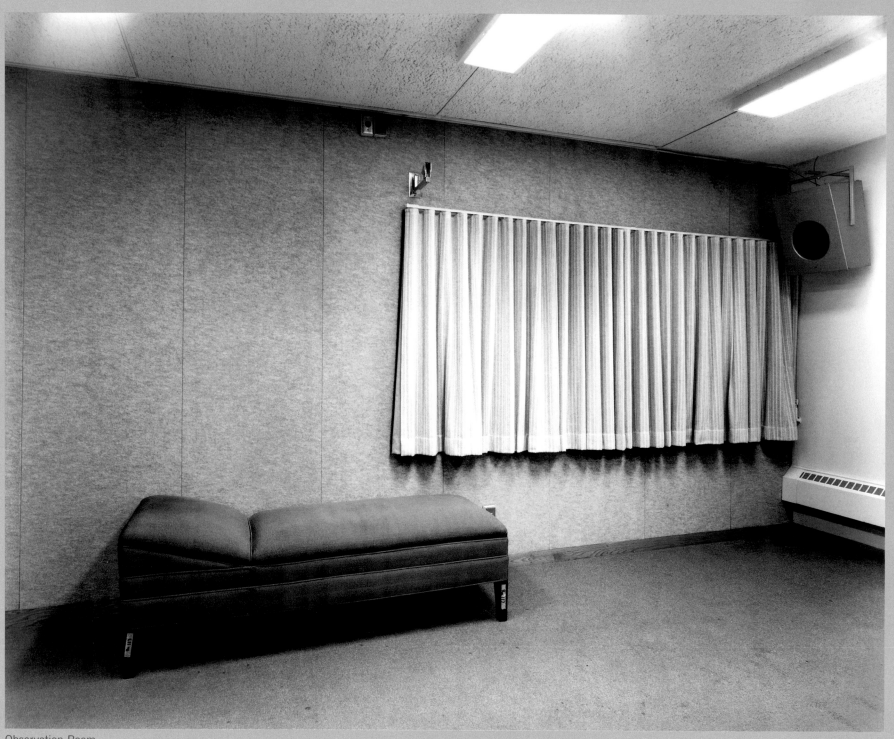

Observation Room

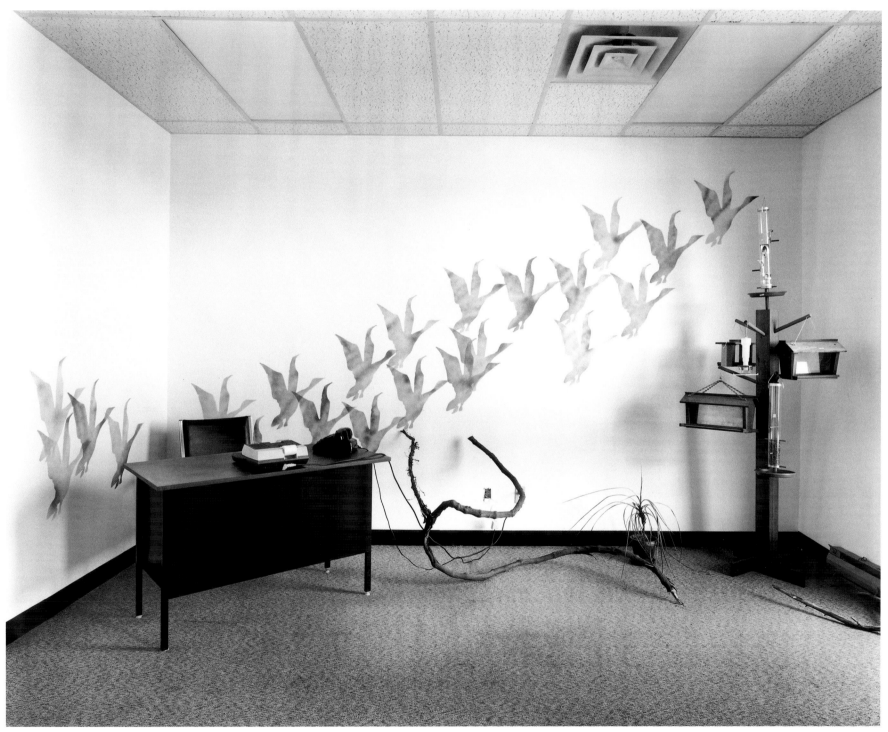

Office and Showroom

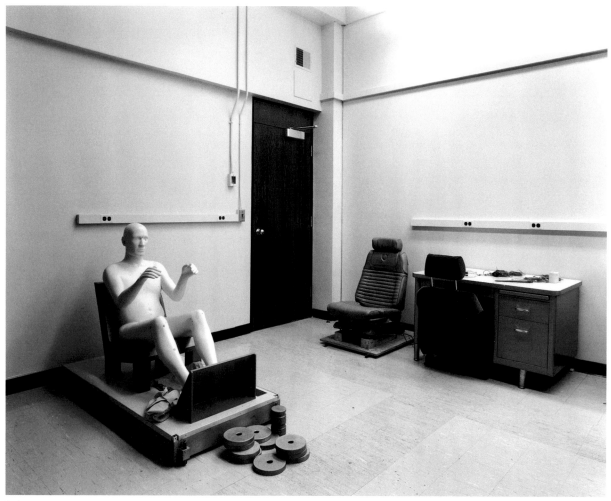

Laboratory

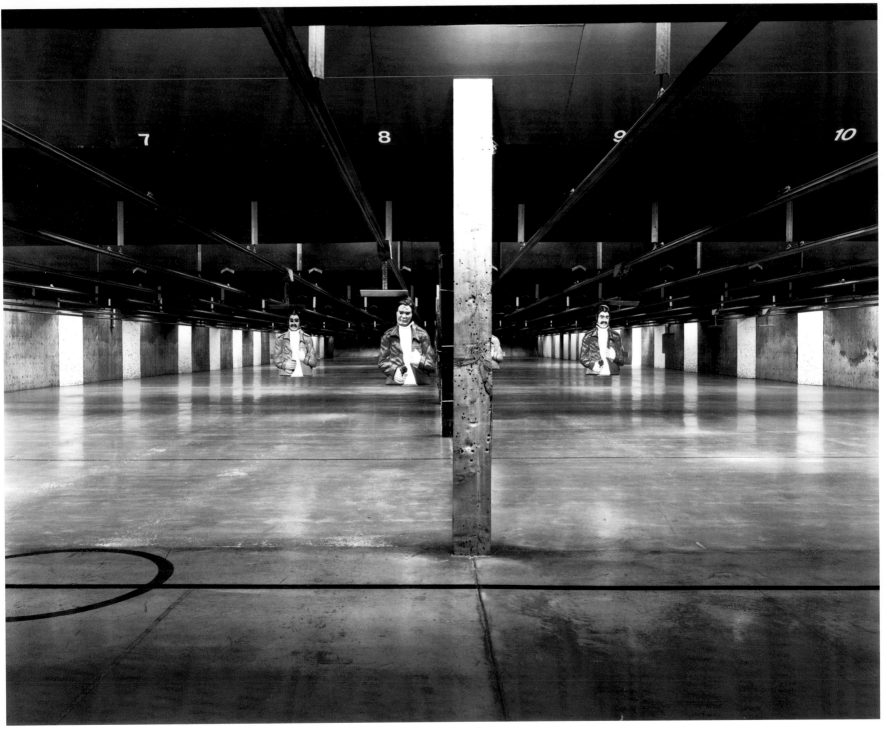

Classroom

Neutral Ground

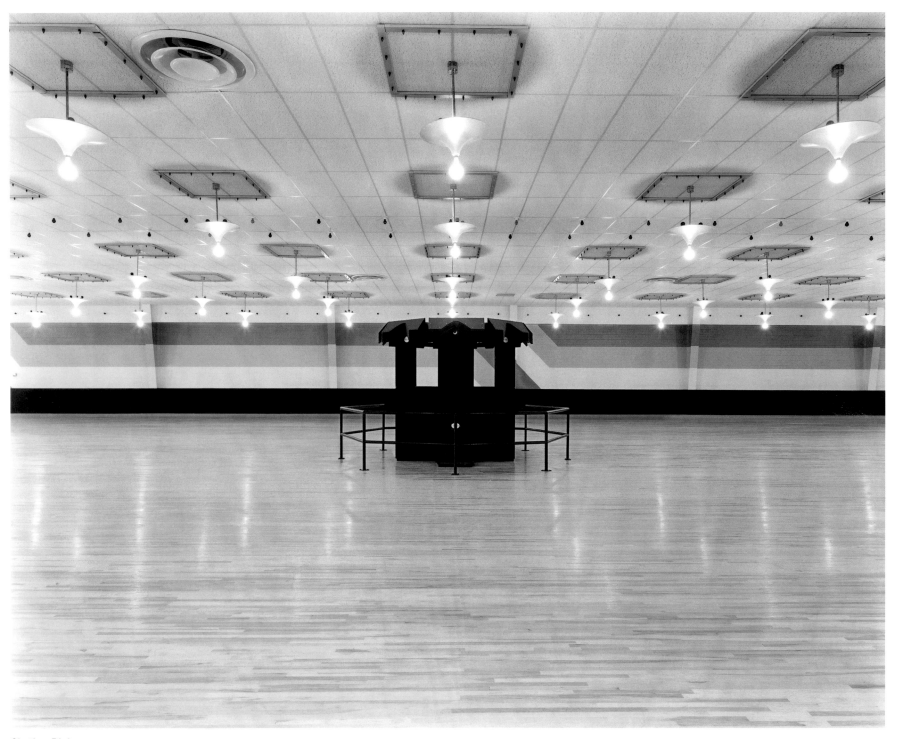

Skating Rink

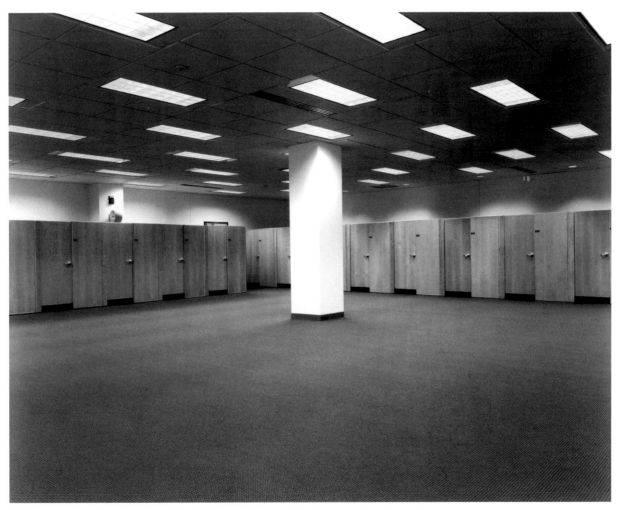

Workroom

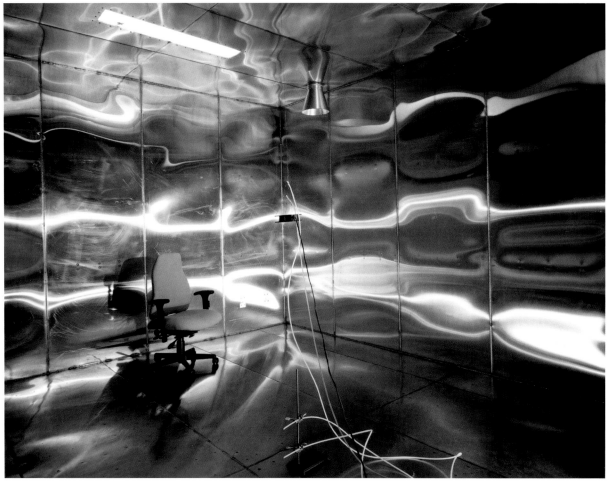

Laboratory

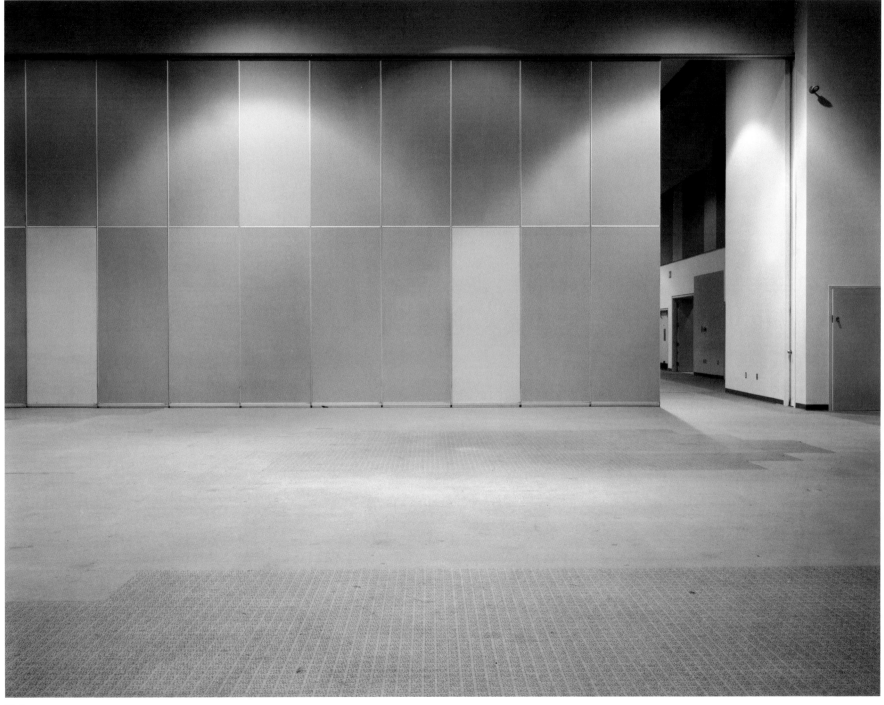

Hall

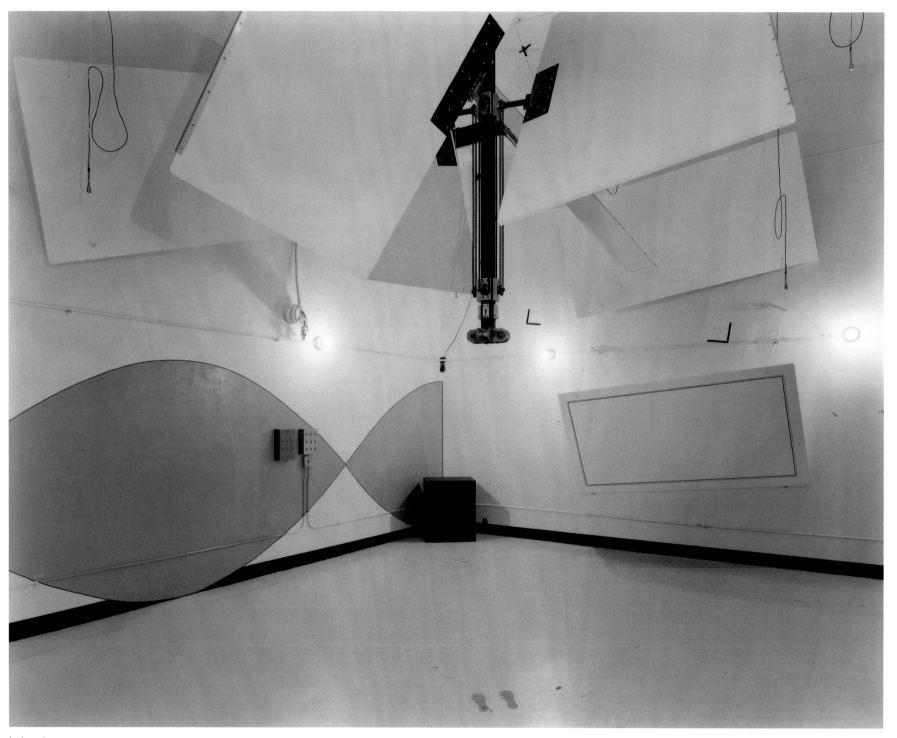

Laboratory

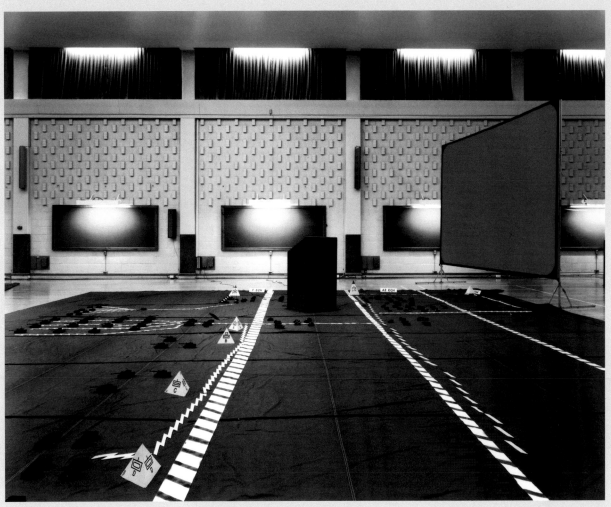

Classroom

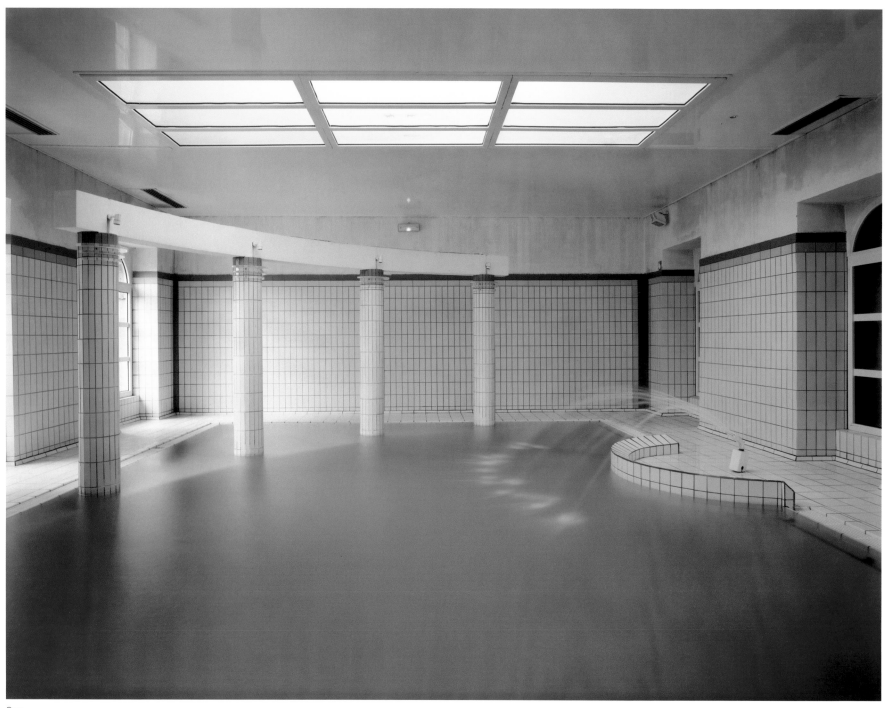

Spa

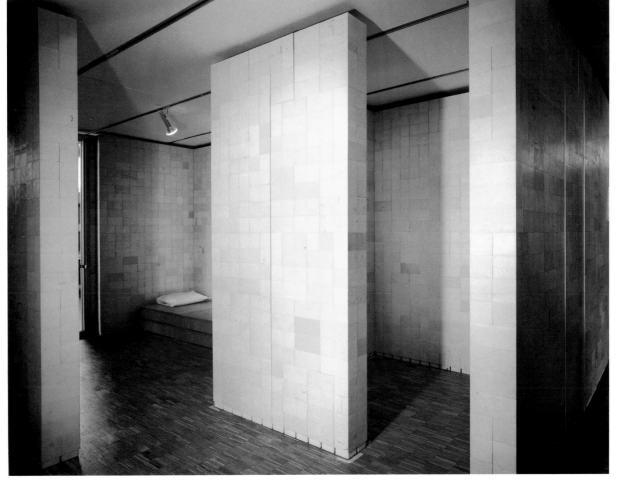

Laboratory

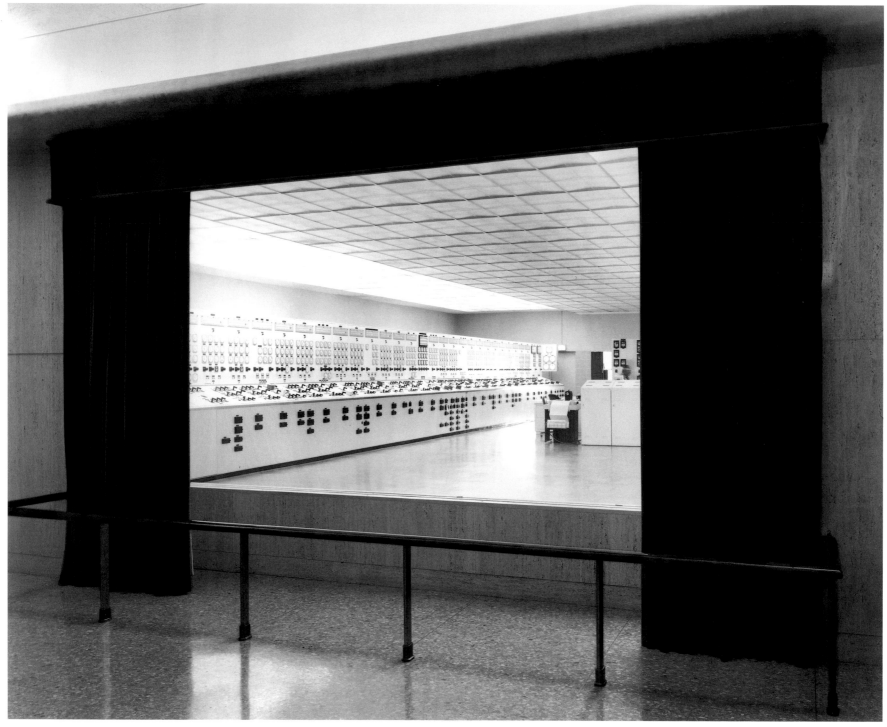

Corridor

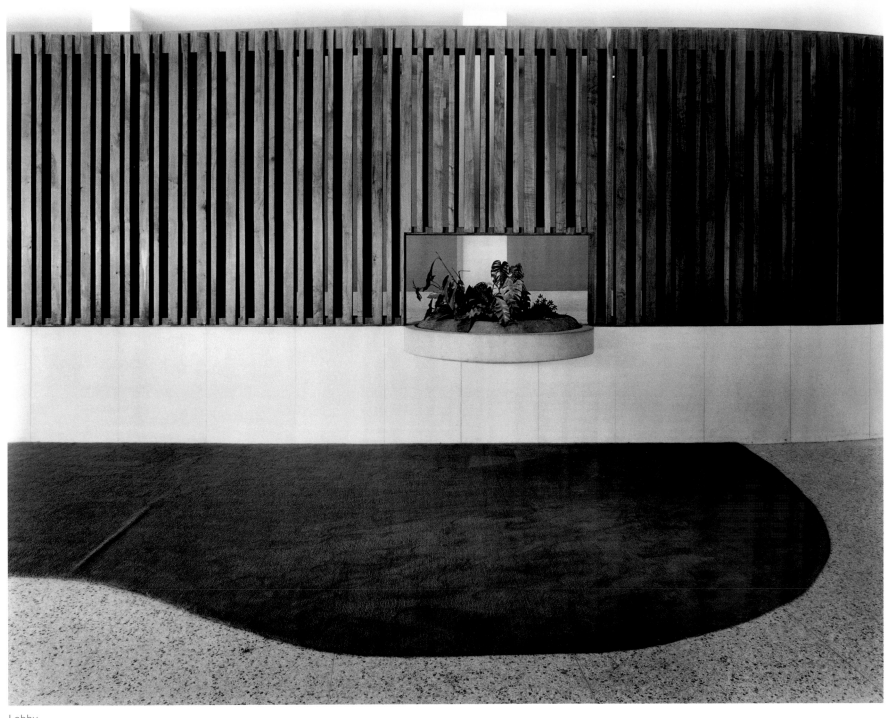

Lobby

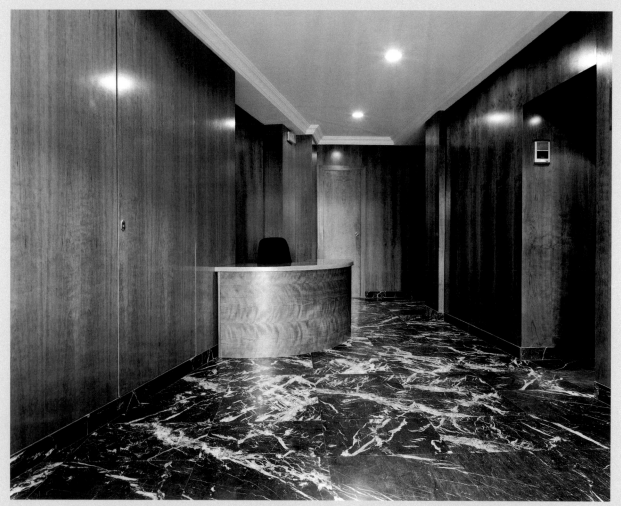

Lobby

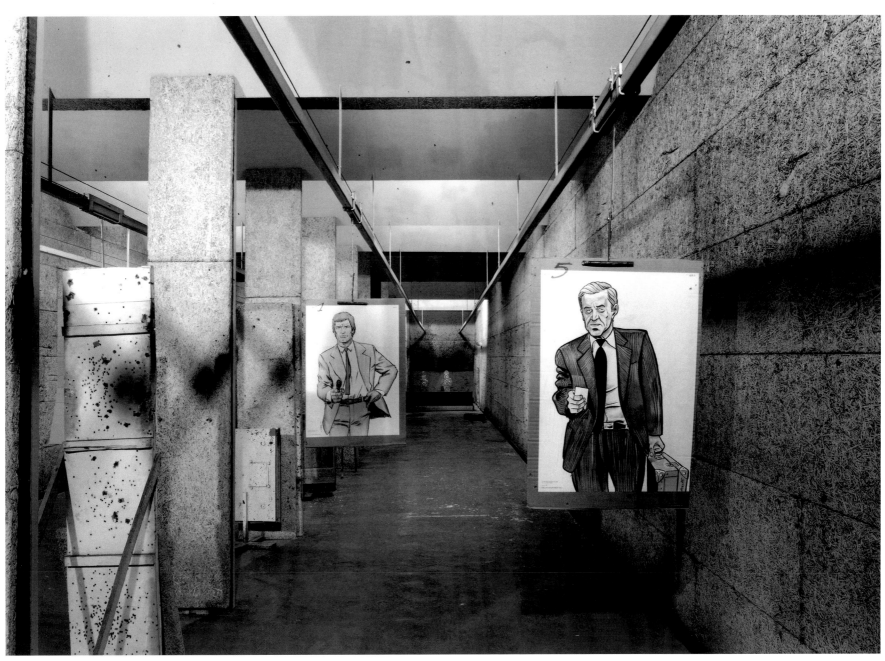

Police Range

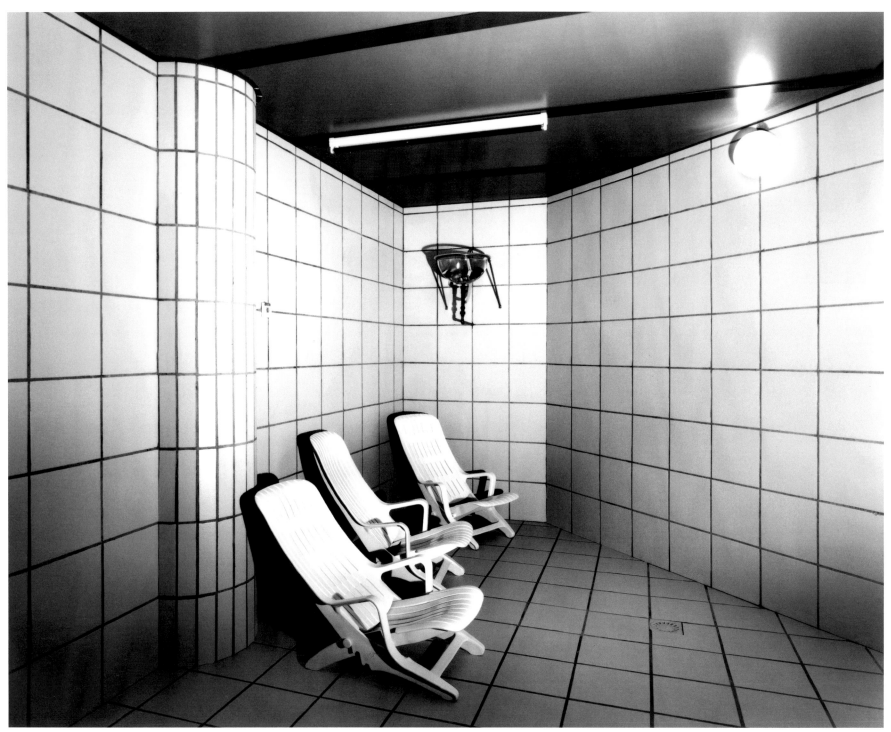

Spa

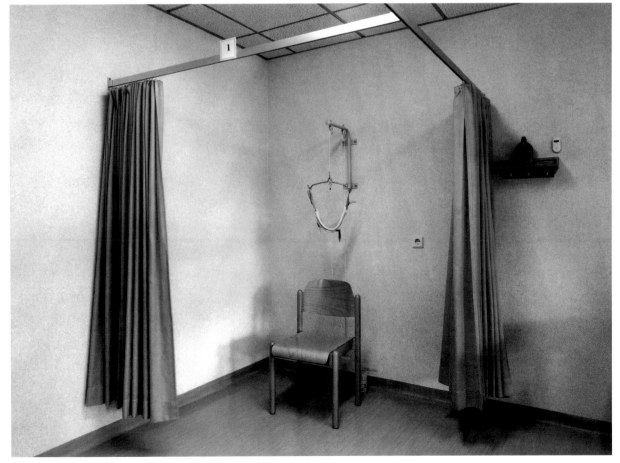

Spa

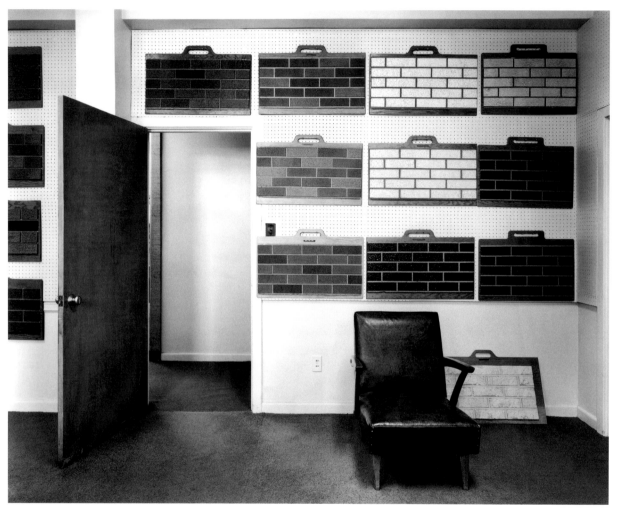

Office and Showroom

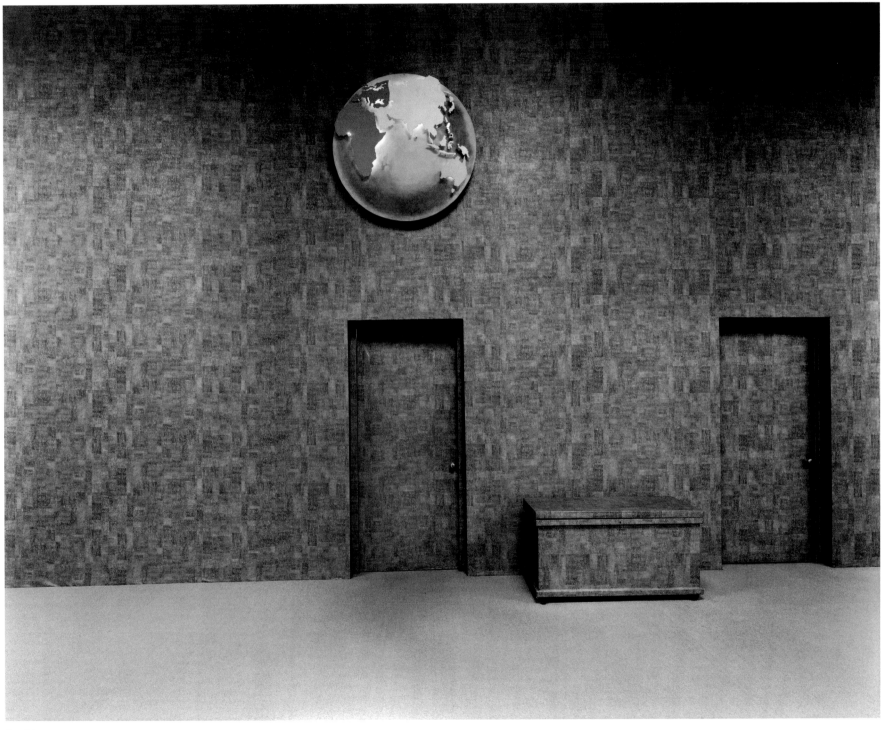

Corridor

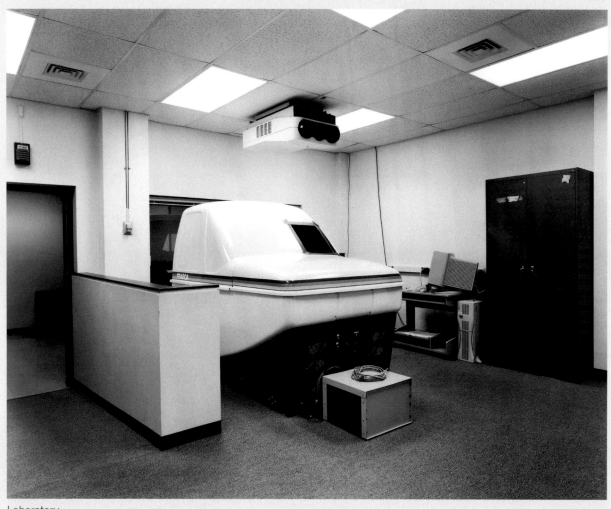

Laboratory

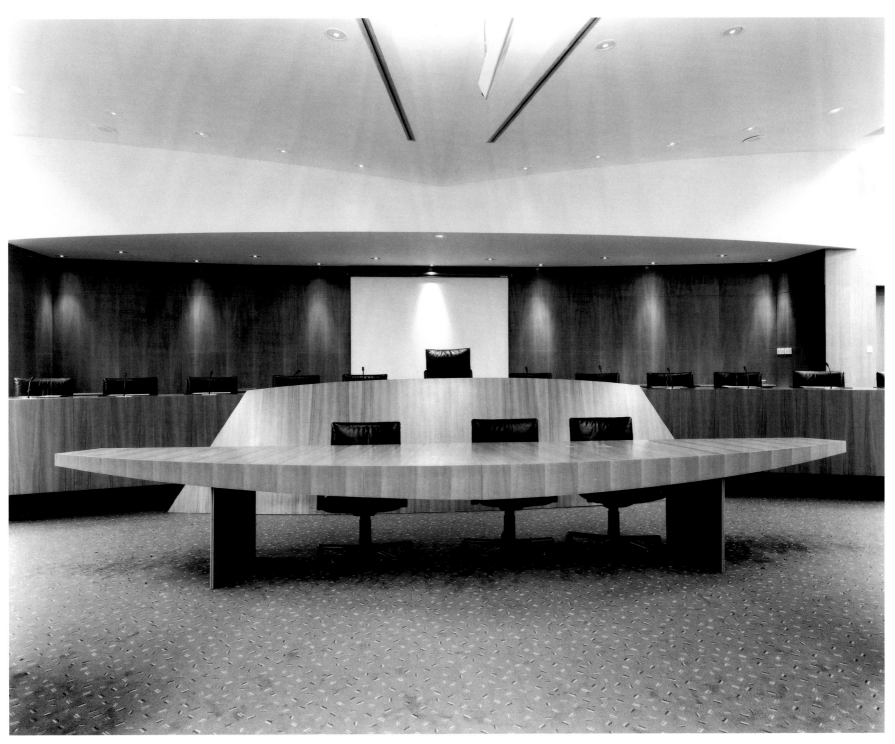

Conference Room

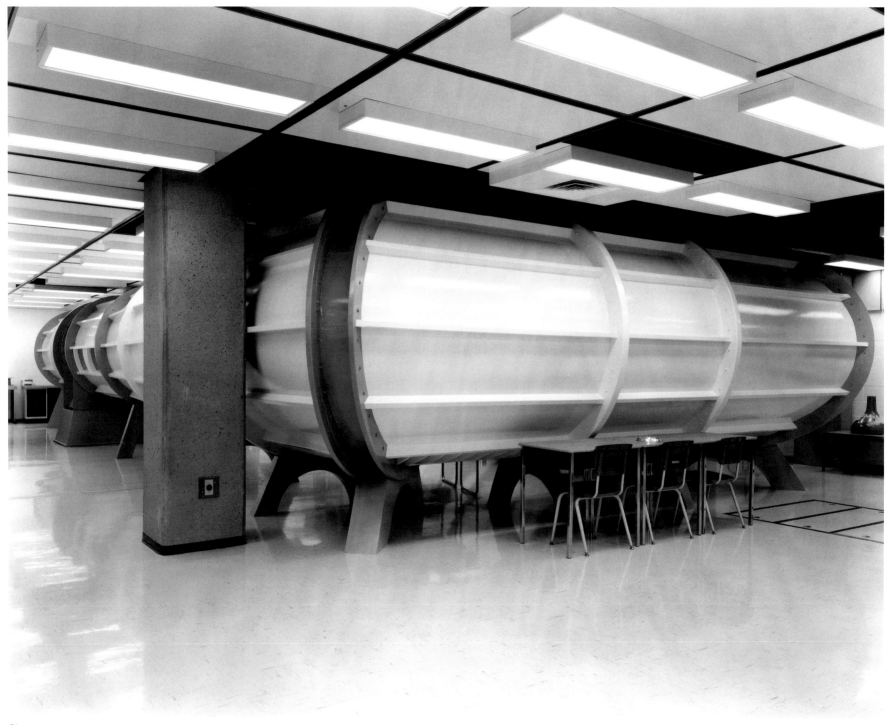

Classroom

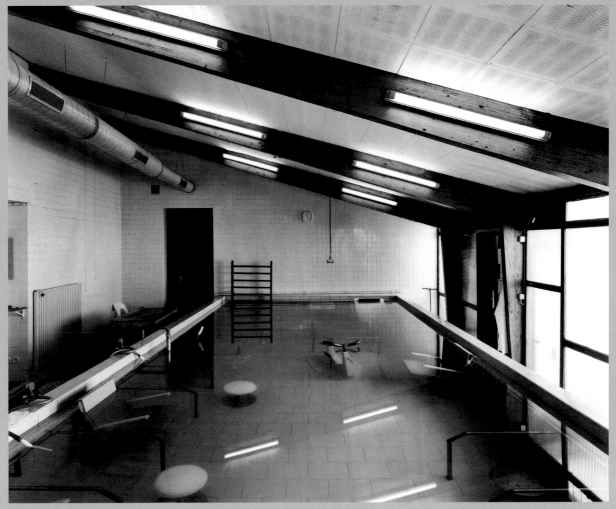

Spa

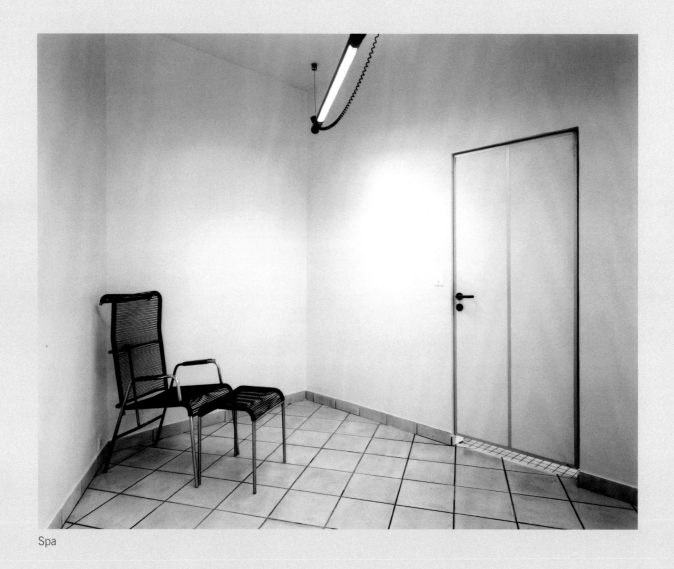

Spa

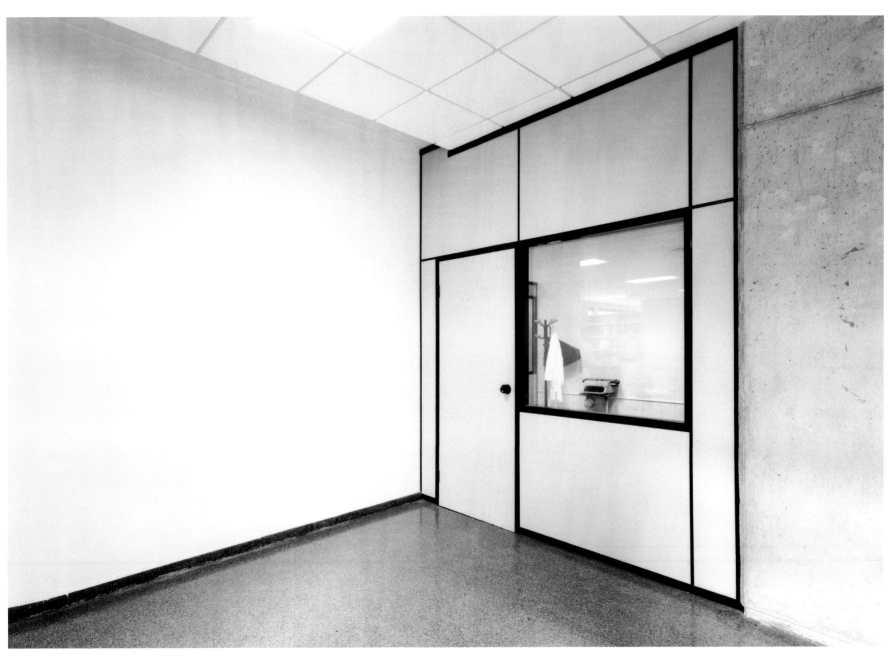

Corridor

LIST OF ILLUSTRATIONS

CHRONOLOGY

1944
July 3, born Racine, Wisconsin, USA.
1962–64
University of Wisconsin, Madison, Wisconsin.
1964–65
Slade School of Art, University of London, London, England.
1967
B.S. in Fine Arts and Art Education, University of Wisconsin.
Logan Award, 71st Annual Exhibition of Artists of Chicago and Vicinity, Chicago Art Institute.
Scholarship, Ox-Bow Summer School of Painting, Michigan.
1968–1973
Eastern Michigan University, Ypsilanti: Teaching Fellow (1968); Lecturer (1969–1970); Instructor (1970–73).
1969
M.A., Eastern Michigan University, Ypsilanti.
1973
Moves to Ottawa, Ontario, Canada.
1974
Teaches in the Visual Arts Department at the University of Ottawa up to the present.
1975
Receives first Canada Council grant (Project Cost). From 1975 to 2000 is regular recipient of various grants from the Canada Council. Receives intermittent awards from the Ontario Arts Council in the late 1970s, the early 1980s and the early 1990s.
1984
Teaches at the School of the Art Institute of Chicago.
1988
Artist in Residence, Light Work, Syracuse University, Syracuse, New York.
1989
Photo/Design Competition, Merit Award for *Occupied Territory*.
1991
Artist in Residence, Centre d'Art Contemporain de Guérigny, France.
Canada Council Victor Martyn Lynch-Staunton Award.
1992
Teaches at the School of the Art Institute of Chicago.
1993
Artist in Residence, Ecole des Beaux-Arts de Bordeaux, France.

Artist in Residence, Ecole des Beaux-Arts de Paris (Préfiguration).
Artist in Residence, International Photography Seminar, Alden Biesen, Belgium.
1994
Artist in Residence, Ecole des Beaux-Arts de Bordeaux, France.
Artist in Residence, Arteleku, San Sebastian.
1995
Artist in Residence, Light Work, Syracuse University, Syracuse, New York.
Artist in Residence, Ecole Nationale de la Photographie, Arles, France.
Member, Jury, Ecole Nationale de la Photographie, Arles, France.
1996
Artist in Residence, Ecole des Beaux-Arts de Bordeaux, France.
Artist in Residence, Nova Scotia College of Art and Design, Halifax, Nova Scotia.
Artist in Residence, Wexner Center for the Arts, Columbus, Ohio.
1998
Artist in Residence, Museum voor Fotografie, Antwerp, Belgium.
Artist in Residence, Universitat de Valencia, Spain.
1999
Artist in Residence, Academie Sint Joost, Breda, Netherlands.
2000
Artist in Residence, Academie Sint Joost, Breda, Netherlands.
2000–2001
Artist in Residence, Hoger Instituut voor Schone Kunst, Antwerp, Belgium.

LIST OF EXHIBITIONS

Solo Exhibitions

1973
A Space, Toronto, Ontario, Canada.
1975
ASA Gallery, University of New Mexico, Albuquerque, New Mexico, USA.
Yajima Gallery, Montréal, Québec, Canada.
1978
Carpenter Center for Visual Arts, Harvard University, Cambridge, Massachusetts, USA.
'Futuric Scientific Place and Other Spaces', International Center of Photography, New York City, USA.
Yarlow/Salzman Gallery, Toronto, Ontario, Canada.
1979
'Lynne Cohen', Light Work Gallery, Syracuse, New York, USA.
1981
The Floating Gallery, Winnipeg, Manitoba, Canada.
1983
Brown University, Providence, Rhode Island, USA.
1984
'Nonfictions', Nova Scotia College of Art and Design, Halifax, Nova Scotia, Canada.
1986
'Matters of Fact', Gallery 49th Parallel, New York City, USA.
1987
'Subversive Plots', Printworks Gallery, Chicago, Illinois, USA.
1988
Art Gallery of Windsor, Windsor, Ontario, Canada.
Galerie Samia Saouma, Paris, France.
Interim Art, London, England.
'Occupied Territory', P.P.O.W., New York City, USA.
1989
Museum für Gestaltung, Zurich, Switzerland.
'Occupied Territory', Art 45, Montréal, Québec, Canada.
The Photographers' Gallery, Toronto, Ontario, Canada.
Sweger Konst, Stockholm, Sweden.
1990
'D'un art l'autre', Galerie Samia Saouma, Paris, France.
Galerie Gokelaere & Janssen, Brussels, Belgium.

Owens Art Gallery, Mount Allison University, Sackville, New Brunswick, Canada.
Printworks, Chicago, Illinois, USA.
1991
Mackenzie Art Gallery, Regina, Saskatchewan, Canada.
1992
Anderson Gallery, Virginia Commonwealth University, Richmond, Virginia, USA.
Art Gallery of York University, Toronto, Ontario, Canada.
Chinati Foundation, Marfa, Texas, USA.
'L'Endroit du décor', F.R.A.C. – Limousin, Limoges, France.
'Half Truths', Carleton University, Ottawa, Ontario, Canada.
P.P.O.W., New York City, USA.
Robert Klein Gallery, Boston, Massachusetts, USA.
1993
Ehlers Caudill Gallery, Chicago, Illinois, USA.
'Foire d'art actuel', Galerie Rodolphe Janssen, Brussels, Belgium.
'Lost and Found', Robert Koch Gallery, San Francisco, California, USA.
'Work from the 70's', P.P.O.W., New York City, USA.
1994
'Incriminating Evidence', Louise Spence Gallery, Toronto, Ontario, Canada.
1995
Galerie Rodolphe Janssen, Brussels, Belgium.
Karsten Schubert Gallery, London, England.
Robert Klein Gallery, Boston, Massachusetts, USA.
1996
'Plus vrai que nature', Galerie des Archives, Paris, France.
P.P.O.W., New York City, USA.
1998
'Lynne Cohen', Museum voor Fotografie, Antwerp, Belgium.
'Neither Here Nor There', Kirkland Fine Arts Center, Millikin University, Peoria, Illinois, USA.
1999
'Signs of Life', Galerie Christiane Chassay, Montréal, Québec, Canada.
2000
Centro de Fotografía, Universidad de Salamanca, Salamanca, Spain.
'Common Ground', P.P.O.W., New York City, USA.

'Espais', Galería Visor, Valencia, Spain.
Galerie Rodolphe Janssen, Brussels, Belgium.
'Lynne Cohen', Olga Korper Gallery, Toronto, Ontario, Canada.
2001
'Lynne Cohen', Galerie Wilma Tolksdorf, Frankfurt, Germany.
'Signs of Life', Galería dels Angels, Barcelona, Spain.

Group Exhibitions

1973
'Photography: Midwest Invitational', Walker Art Center, Minneapolis, Minnesota, USA.
1974
'American Moods', Whitney Museum of American Art, New York City, USA.
Goddard College, Plainfield, Vermont, USA.
Henry Gallery, University of Washington, Seattle, Washington, USA.
'Wish You Were Here: The History of the Picture Postcard', The Joe and Emily Lowe Gallery, Syracuse, New York, USA.
1975
'Exposure: Canadian Contemporary Photographers', National Film Board of Canada, Ottawa, Ontario, Canada.
1976
'Destination Europe: Six Canadian Photographers', Optica Gallery, Montréal, Québec, Canada.
'Five Photographers', Owens Art Gallery, Mount Allison University, Sackville, New Brunswick, Canada.
'The Photographers' Choice', Witkin Gallery, New York City, USA.
University of New Mexico Art Museum, Albuquerque, New Mexico, USA.
1977
Art Gallery of Ontario, Toronto, Ontario, Canada.
'New Acquisitions', National Gallery of Canada, Ottawa, Ontario, Canada.
'Rooms', Museum of Modern Art, New York City, USA.
1978
'Silences et Stridences: Lynne Cohen/ Robert Walker', Galerie Delpire, Paris, France.
Yajima Gallery, Montréal, Québec, Canada.
1979
'The Banff Purchase', Walter Phillips Gallery, Banff, Alberta, Canada.
CEPA Gallery, Buffalo, New York, USA.
1980
Douglas Kenyon Gallery, Chicago, Illinois, USA.
'The Magical Eye', National Gallery of Canada, Ottawa, Ontario, Canada.
'Master 19th and 20th Century Photographs', Centre Saidye Bronfman, Montréal, Québec, Canada.
Skidmore College, Saratoga Springs, New York, USA.
'22 Women', Light Work Gallery, Syracuse, New York, USA.
Yajima Gallery, Montréal, Québec, Canada.
1981
'Les Choix de l'Oeil', Musée d'Art Contemporain, Montréal, Québec, Canada.
'The Mask of Objectivity: Subjective Images', McIntosh Gallery, University of Western Ontario, London, Ontario, Canada.

'Points of View', Musée des Beaux-Arts à Montreal, Montréal, Québec, Canada.
'Suite-Série-Séquence', Le Centre Culturel Graslin, Nantes, France.
1982
'New Vintage', The Photographers' Gallery, Saskatoon, Saskatchewan, Canada.
1983
'Latitudes and Parallels: Focus on Contemporary Canadian Photography', Winnipeg Art Gallery, Winnipeg, Manitoba, Canada.
'Lynne Cohen, Vincent Sharp, Geoffrey James', Yarlow/Salzman Gallery, Toronto, Ontario, Canada.
1984
'Art Bank Collection', Presentation House, Vancouver, British Columbia, Canada.
'La Photographie créatif', Bibliothèque nationale, Pavillon des Arts, Paris, France.
'Responding to Photography', Art Gallery of Ontario, Toronto, Ontario, Canada.
'Seeing People, Seeing Space: Contemporary Photography from Ontario, Canada', The Photographers' Gallery, London, England.
Yajima Gallery, Montréal, Québec, Canada.
1985
Coburg Gallery, Vancouver, British Columbia, Canada.
'Environments Here and Now: Three Contemporary Photographers, Lynne Cohen, Robert Del Tredici, Karen Smiley', National Gallery of Canada, Ottawa, Ontario, Canada.
'From the Collection of the National Film Board', Ottawa, Ontario, Canada.
1986
'Dissolution', P.P.O.W., New York City, USA.
1987
'Heresies', P.P.O.W., New York City, USA.
'Modern Living', Jeffrey Linden Gallery, Hollywood, California, USA.
1988
'Art and the Law', Rose Art Museum, Brandeis University, Brandeis, Massachusetts, USA.
'Democracy I', 'Democracy II' and 'Democracy III', Dia Art Foundation, New York City, USA.
'Dislocations', Aperture Gallery, New York City, USA.
'Situations', Museum of Modern Art, New York City, USA.
1989
Galerie Samia Saouma, Paris, France.
'150 Years of Photography', Manes Gallery, Prague, Czechoslovakia.
'Photography Now', Victoria and Albert Museum, London, England.
'Power Plays', Stills Gallery, Edinburgh, Scotland.
P.P.O.W., New York City, USA.
'Shifting Focus', Arnolfini Gallery, Bristol, England.
'Still Surreal', Sarah Lawrence College, Bronxville, New York, USA.
1990
Biennale Internationale de Marseille, Marseilles, France.
'Cultural Artifacts', Ehlers Caudill Gallery, Chicago, Illinois, USA.
Galerie Samia Saouma, Paris, France.
'Living Evidence: Lynne Cohen and Roger Mertin', Presentation House Gallery, Vancouver, British Columbia, Canada.

'Silent Interiors', Security Pacific Gallery, Seattle, Washington, USA.
Weatherspoon Art Gallery, University of North Carolina, Greensboro, North Carolina, USA.
1991
'L'Effet de Réel', Galerie Art & Essai, Université de Rennes, Rennes, France.
Galerie Gokelaere & Janssen, Brussels, Belgium.
'Location and Displacement', Saw Gallery, Ottawa, Ontario, Canada.
'Lynne Cohen, Thomas Struth, Christopher Williams', Galerie Samia Saouma, Paris, France.
'Nouvelles acquisitions', F.R.A.C. – Limousin, Limoges, France.
'Das Sibyllinische Auge', Barbara Gross Galerie, Munich, Germany.
'To Wit', Rosa Esman Gallery, New York City, USA.
'Typologies: Nine Contemporary Photographers', Newport Harbor Art Museum, Newport Harbor, California, USA.
'Un-Natural Traces: Contemporary Art from Canada', Barbican Art Gallery, London, England.
'Working Truths/Powerful Fictions', Mackenzie Art Gallery, Regina, Saskatchewan, Canada.
1991–1993
'No Laughing Matter', University Gallery, University of North Texas, Denton, Texas, USA.
1992
'Beau', Canadian Museum of Contemporary Photography, Ottawa, Ontario, Canada.
'Beyond Glory: Re-presenting Terrorism', Maryland Institute, College of Art, Maryland, Baltimore, USA.
'De la Curiosité: petite anatomie d'un regard', Dazibao, Montréal, Québec, Canada.
Galerie Rodolphe Janssen, Brussels, Belgium.
'Hats and Headgear', San Francisco Museum of Modern Art, San Francisco, California, USA.
'Photography Without Apology', Emily Carr College of Art and Design, Vancouver, British Columbia, Canada.
'Representatives', Center for Creative Photography, Tucson, Arizona, USA.
'La collection: Tableau inaugural', Musée d'Art Contemporain, Montréal, Québec, Canada.
1993
Davis Museum, Wellesley College, Wellesley, Massachusetts, USA.
'Magicians of Light', National Gallery of Canada, Ottawa, Ontario, Canada.
'Observing Traditions', National Gallery of Canada, Ottawa, Ontario, Canada.
P.P.O.W., New York City, USA.
'Vivid: Intense Images by American Photographers', Raab Galerie, Berlin, Germany.
1994
P.P.O.W., New York City, USA.
'La Ville: Intimité et froideur', Galerie des Archives, Paris, France.
1995
'Beyond Recognition: Contemporary International Photography', National Gallery of Australia, Canberra, Australia.
'Double Mixte (Barry X. Ball, Lynne Cohen, Pascal Convert, Rachel Whiteread)', Galerie Nationale du Jeu de Paume, Paris, France.

'Pure Hinterland', Randolph Street Gallery, Chicago, Illinois, USA.
'Rituals and Transformations', National Gallery of Canada, Ottawa, Ontario, Canada.
'Visions of Hope and Despair', Museum of Contemporary Art, Chicago, Illinois, USA.
1996
'Celebrating a Vision', National Gallery of Canada, Ottawa, Ontario, Canada.
'Embedded Metaphor', John and Mabel Ringling Museum of Art, Sarasota, Florida, USA.
Galerie Rodolphe Janssen, Brussels, Belgium.
'A History of Women Photographers', New York Public Library, New York City, USA.
'Passions Privées', Musée d'Art Moderne de la ville de Paris, Paris, France.
Stephen Bulger Gallery, Toronto, Ontario, Canada.
'Summer of Photography', MUHKA, Antwerp, Belgium.
'What Makes a Nation?', Art Gallery of Ontario, Toronto, Ontario, Canada.
1997
'Burkhard, Cohen, Griffiths, Ruff', Galerie Rodolphe Janssen, Brussels, Belgium.
Cranbrook Art Museum, Cranbrook, Michigan, USA.
'Design for Living', Galerie CC Ten Weyngaert, Vorst, Belgium.
'Evidence: Photography and Site', Wexner Center for the Arts, Columbus, Ohio, USA.
'In Our Sights', University of Tampa Art Gallery, Tampa, Florida, USA.
'Objectif Corps', Musée de Beaux Arts à Montréal, Montréal, Québec, Canada.
'Poetic Evidence', National Gallery of Canada, Ottawa, Ontario, Canada.
P.P.O.W., New York City, USA.
1998
Bowdoin College Museum of Art, Brunswick, Maine, USA.
'Le Donné, le fictif', Centre National de la Photographie, Paris, France.
'Evidence: Photography and Site', Power Plant, Toronto, Ontario, Canada.
The Light Factory, Charlotte, North Carolina, USA.
Musée d'Art Moderne, Villeneuve d'Ascq, France.
'Photography's Multiple Roles', Museum of Contemporary Photography, Columbia College, Chicago, Illinois, USA.
'Under Construction', Olga Korper Gallery, Toronto, Ontario, Canada.
'The Word in Contemporary Canadian Art', Art Gallery of North York, Toronto, Ontario, Canada.
1999
'Esuards Distants', IVAM, Valencia, Spain.
'Photoworks 1900–1999', Culturgest, Lisbon, Portugal.
2000
'Le Siècle du Corps', Musée de l'Elysée, Lausanne, Switzerland.
'Lynne Cohen', Art Brussels, Brussels, Belgium.

SELECT BIBLIOGRAPHY

Books

Occupied Territory, New York: Aperture Foundation, 1987. Edited and designed by William A. Ewing; texts by David Byrne and David Mellor.

Paul, Frédéric, *Lynne Cohen: l'Endroit du décor/Lost and Found*, Limoges: Fonds régional d'art contemporain Limousin, Paris: Hotel des Arts, 1992. Interview by Ramon Tio Bellido with Lynne Cohen.

Exhibition Catalogues

Andries, Pool, *American Photographs 1940–1990*, Antwerp: Museum voor Fotografie, 1990.

Arcand, Bernard, *et al.*, *De la Curiosité: petite anatomie d'un regard*, Montréal: Dazibao, 1992.

Arthus-Bertrand, Catherine, *La Nièvre photographiée*, Nevers: Conseil Général de la Nièvre, 1994.

Borcoman, James, *Magicians of Light*, Ottawa: National Gallery of Canada, 1993.

Bradley, Jessica, *Working Truths/Powerful Fictions*, Regina: Mackenzie Art Gallery, 1992.

Brown, Carol and Bruce Ferguson, *Un-Natural Traces: Contemporary Art from Canada*, London: Barbican Art Gallery, 1991.

Butler, Susan, *Shifting Focus: An International Exhibition of Contemporary Women's Photography*, London and Bristol: Serpentine/Arnolfini, 1989.

Christie, Claire, *Under Construction: Bernd & Hilla Becher, Lynne Cohen, Todd Hido*, Toronto: Olga Korper Gallery, 1998.

Criqui, Jean-Pierre, *Double Mixte: Barry X. Ball, Lynne Cohen, Pascal Convert, Rachel Whiteread*, Paris: Galerie nationale du Jeu de Paume, 1995, pp. 11–44.

Davidson, Kate, *Beyond Recognition: Contemporary International Photography*, Canberra: National Gallery of Australia, 1995.

Davies, Sue, *Seeing People, Seeing Space: Contemporary Photography from Ontario*, Toronto: Visual Arts Ontario, 1984.

de Duve, Thierry, *Lynne Cohen*, Brussels: Galerie Gokelaere & Janssen, 1990.

Felshin, Nina, *No Laughing Matter*, New York: Independent Curators Inc., 1991.

——, *Embedded Metaphor*, New York: Independent Curators Inc., 1996.

Freidus, Marc, *et al.*, *Typologies: Nine Contemporary Photographers*, Newport Beach, Calif.: Newport Harbor Art Museum, 1991.

Hall, Gary, *et al.*, *Public Exposures: One Decade of Contemporary Canadian Photography 1980–1990*, Toronto: Toronto Photographers' Workshop, 1990.

Kirshner, Judith Russi, *Vivid: Intense Images by American Photographers*, Berlin: Raab Galerie, 1993.

Lamoureux, Johanne, *Lynne Cohen: Stages without Wings*, Toronto: Art Gallery of York University, 1992.

Langford, Martha, *Beau*, Ottawa: Canadian Museum of Contemporary Photography, 1992.

Lanzinger, Pia, *Das Sibyllinische Auge: Fotokünstlerinnen aus dem Anglo-Amerikanischen Raum*, Munich: Foto e.V. München und Barbara Gross Galerie, 1991.

Le Foll, Joséphine, *Maison française*, October 1988.

Lussier, Real, 'Lynne Cohen', *Les vingt ans du Musée à travers sa collection*, Musée d'Art Contemporain de Montréal, 1985, p. 74.

Madill, Shirley, *et al.*, *Latitudes and Parallels: Focus on Contemporary Canadian Photography*, Winnipeg, Manitoba: Winnipeg Art Gallery, c. 1983.

Marguerin, Jean-François, *Trafic*, Haute-Normandie: Frac, 1998.

Milrod, Glenda and Shin Sugino, eds, *Exposure: Canadian Contemporary Photographers*, Toronto: Art Gallery of Ontario, 1975.

Monk, Lorraine, ed., *The Female Eye/Coup d'oeil féminin*, Toronto: Clarke, Irwin in collaboration with the National Film Board of Canada, Still Photography Division, 1975.

Peat, David F., *Art, Document, Market, Science: Photography's Multiple Roles*, Chicago: Museum of Contemporary Photography, 1998.

Powell, Robert, *Power Plays*, Edinburgh: Stills Gallery, 1989.

Robbins, Mark, *On the Table*, Columbus, Ohio: Wexner Center for the Arts, 1999.

Rogers, Sarah J. and Mark Robbins, *Evidence: Photography and Site*, Columbus, Ohio: Wexner Center for the Arts, 1997.

Sànchez Durá, Nicolás and Jon J. Juáristi, *Esuards Distants*, Valencia: IVAM & Universidad de València, 1999.

Slemmons, Rod, *Living Evidence: Lynne Cohen, Roger Mertin*, Vancouver: Presentation House Gallery, 1991.

St-Pierre, Gaston, 'Les Chambres blanches', *Le Souci du document*, Les 400 Coups, Montréal, 1999.

Thomas, Ann, *Environments Here and Now: Three Contemporary Photographers, Lynne Cohen, Robert Del Tredici, Karen Smiley*, Ottawa: National Gallery of Canada, 1985.

Articles

Agboton-Jumeau, Jean-Charles, 'Lynne Cohen', *Forum International*, vol. IV, no. 19 (October–November 1993), pp. 94–97.

Aletti, Vince, 'Lynne Cohen', *Village Voice*, 24 May 1988, p. 53.

——, 'Lynne Cohen', *Village Voice*, 1 February 2000.

Ardenne, Paul, 'Double mixte', *Art Press*, no. 202 (May 1995), p. 82.

Baele, Nancy, 'Meaning of Humanity in Empty Rooms', *Ottawa Citizen*, 24 September 1988, p. C2.

——, 'What You Get Depends on What You See', *Ottawa Citizen*, 1 March 1993, p. B10.

Baker, Kenneth, 'Lynne Cohen: Robert Koch', *Artnews*, vol. 92, no. 9 (November 1993), p. 172.

Barendse, Henri Man, 'Photos Reflect Our Culture', *New Mexico Daily Lobo*, 12 February 1975.

Baudier, Denis, 'La Frontalité de Lynne Cohen', *Art Press*, vol. 130 (November 1988), p. 67.

Beck, H., 'Menschenleere Laboratorien', *Frankfurter Allgemeine Zeitung*, 5 March 2001, p. S61.

Breerette, Geneviève, 'Double mixte', *Le Monde*, 12 April 1995, p. 26.

Bufill, J., 'Los decorados encontrados de Cohen', *La Vanguardia*, 9 February 2001, p. 15.

Butler, Susan, 'Subject-to-Change', *Women's Art Magazine*, no. 59 (July–August 1994), pp. 22–26.

——, 'The Mise-en-scene of the Everyday', *Art and Design*, no. 10 (September/October 1995), pp. 17–23.

—— and Liz Wells, 'Shifting Focus', *Creative Camera*, vol. 7, 1989, p. 32.

Campeau, Sylvain, 'De la curiosité', *Parachute*, no. 68 (October, November, December 1992), p. 56.

——, 'Espaces revelateurs', *Parachute*, no. 57 (January, February, March 1990), p. 52.

Charron, Marie-Eve, 'Gros Plan sur l'imperfection', *La Presse*, 11 September 1999, p. D13.

Corey Phillips, Carol, 'Speaking through Silence: The Female Voice in the Photography of Nina Raginsky, Clara Gutsche and Lynne Cohen', *Thirteen Essays on Photography*, Ottawa: Canadian Museum of Contemporary Photography, 1990, p. 113.

Cornand, Brigitte, 'Lynne Cohen', *Beaux Arts Magazine*, no. 104 (September 1992), pp. 96–97.

Cousineau, Penny, 'Lynne Cohen', *Arts Canada*, no. 222/223 (October/November 1978), p. 68.

——, 'Two Photographic Exhibitions', *Parachute*, no. 4 (Autumn 1976), pp. 6–9.

Cron, Marie-Michelle, 'L'Art de la cruauté', *Le Devoir*, 18 April 1992, p. C9.

Dagbert, Anne, 'Double Mixte: Jeu de Paume', *Artforum*, vol. 33, no. 10 (Summer 1995), p. 116.

Danckaert, B., 'Ersatz en kinderspeelgoed', *Tijd Culture*, 2 February 2000, p. 10.

——, 'Foto's als een samenloop van omstandigheden', *De Financieel-Economische Tijd*, 26 February 2000, p. 10.

Dault, Gary Michael, 'Destination Europe', *Artscanada*, no. 212/213 (March/April 1977), p. 60.

——, 'Lynne Cohen, Vincent Sharp, Geoffrey James: Yarlow/Salzman', *Vanguard*, vol. 12, no. 3 (April 1983), p. 29.

——, 'Photos Probe Meaning', *Globe and Mail*, 25 July 1998, p. C15.

de Vos, Johan, 'Binnen is het proper', *Knack*, 1 March 2000, p. 69.

——, 'De geur van het nest', *Knack*, 7 March 1990, p. 139.

del Rio, Victor, 'Lynne Cohen', *Lapiz* 162 (April 2000), p. 78.

Demurgé, Gilles, 'FRAC: L'art sort du cadre', *Les magazines de France* (November 1992), pp. 10–11.

Durand, Régis, *D'un art, l'autre*, Marseilles: Images en Manoeuvres Editions, 1990, pp. 214–215.

——, 'Lynne Cohen ou l'effet de coupe', *Art Press*, vol. 145 (6 March 1990), pp. 45–47. Reprinted in Régis Durand, *La part de l'ombre: essais sur l'expérience photographique*, Paris: La Différence, 1990.

Eauclaire, Sally, 'Cohen Turns the Everyday into the Surreal: Subversive Plots', *Chicago Tribune*, 23 January 1987, sec. 7, p. 65.

Edwards, Owen, 'The Emptiness of Our Empty Rooms', 'The Arts', *Saturday Review*, 8 July 1978, pp. 20–21.

Eelbode, Erik, 'Gevonden plaatsen: On parle mieux de l'homme quand il n'est pas la' ('Found places'), *De Witte Raaf*, no. 46 (November 1993), p. 23.

Ericsson, Lars O., 'Lynne Cohen foto: Framhiden har intraffat' ('The Future Has Occurred'), *Dagens Nyheter*, December 1989, p. 4.

Ewing, William A., 'Lynne Cohen: Room Readings', *Aperture*, no. 106 (Spring 1987), p. 24.

Fina, Angela, 'Clicking the Shutter: The Female Eye Is Not All There Is to It'/ 'Coup d'Oeil Feminin', *Matrix*, vol. 1, no. 2 (Fall 1975), pp. 1–2.

Finley, Kathleen, 'Lynne Cohen', *Arts Magazine*, vol. 66, no. 8 (April 1992), p. 73.

Fisher-Taylor, Gail, 'Lynne Cohen Photos at Yarlow/Salzman', *Artmagazine*, no. 43/44 (May/June 1979), pp. 42–43.

——, 'A Journey to the West', *Photo Communiqué*, vol. 1, no. 4 (September/October 1979), p. 6.

——, 'Photography: The Banff Purchase', *Artmagazine*, no. 47 (February/March 1980), p. 25.

Fitzpatrick, Blake, 'Photographing Culture', Toronto Photographers' Workshop, 1985 (pamphlet), p. 2.

Foerstner, Abigail, 'Lynne Cohen: Occupied Territory & Cultural Artifacts', *Chicago Tribune*, 12 January 1990, sec. 7, p. 69.

——, 'Lynne Cohen', *Chicago Tribune*, 30 April 1993, sec. 7, p. 89.

Fry, Jacqueline, 'Un Théatre d'objets de plus en plus inquisiteur', *Parachute*, no. 33 (December, January, February 1983–1984), pp. 4–11.

Fry, Philip, 'Concerning the Wacousta Syndrome', *Sightlines*, Montréal: Artextes éditions, 1994, p. 37. Jessica Bradley and Lesley Johnstone, eds.

Gibson, Wesley, 'Lynne Cohen', *New Art Examiner*, vol. 20, no. 8 (April 1993), p. 36.

Gisbourne, Mark, 'Double Mixte', *Art Monthly*, no. 186 (May 1995), p. 36.

Glowen, Ron, 'The Eloquence of Empty Rooms', *Artweek*, vol. 21, 13 December 1990, p. 13.

Gopnik, Blake, 'Meticulous Cohen Bravely Enters the World of Colour', *Globe and Mail*, 26 April 2000, p. R4.

Gruben, Patricia, 'Pursuit of the Bilateral', *Centerfold* (February/March 1979), p. 126.

Grundberg, Andy, 'Occupied Territory', *New York Times Book Review*, 4 December 1988, p. 20.

Guerrin, Michel, 'Plus réel que nature', *Le Monde*, 7 October 1992, p. 15.

Hagen, Charles, 'Lynne Cohen: 49th Parallel', *Artforum*, vol. 25, no. 2 (October 1986), p. 132.

——, 'Lynne Cohen: P.P.O.W. Gallery', *New York Times*, 17 January 1992, p. C28.

Heller, Martin, 'Fotovision', Sprengel Museum, Hannover, 1988.

——, 'Lynne Cohen', *Der Alltag*, January 1989, p. 21.

Hess, Elizabeth, 'Lynne Cohen: P.P.O.W.', *Village Voice*, 24 May 1988, p. 10.

Hicks, Robert, 'Lynne Cohen at P.P.O.W.', *Villager*, vol. 66, no. 28, 4 December 1996, p. 19.

Hlynsky, David, 'Symbolism and Metaphor in Contemporary Photography', *Blackflash*, vol. 13, no. 2 (Summer 1995), pp. 8–11.

Hugunin, James R., 'Lynne Cohen', *New Art Examiner*, vol. 17 (April 1990), pp. 41–42.

Hume, Christopher, 'Cohen's Real-Life Places Can Look Really Unreal', *Toronto Star*, 23 June 1994, p. H5.

James, Geoffrey, 'Focus: On Lynne Cohen', *Canadian Art*, vol. 5, no. 4 (Winter 1988), p. 92.

Jenkins, William, 'Lynne Cohen: Interiors', *Image*, vol. 17, no. 3 (September 1974), pp. 12–20.

Kaston, Diane, 'Still Surreal' (exhibition notes), Sarah Lawrence College, New York, 1989.

Klinkenberg, Marty, 'Art Can Be No More than an Empty Room', *Ottawa Citizen*, 12 February 2000, p. E11.

Koh, Germaine, 'Lynne Cohen', *Contact Sheet 89*, Light Work, Syracuse, 1996.

L.C., 'Lynne Cohen: L'endroit du décor', *Le Quotidien de Paris*, 8 October 1992, p. 18.

Lamarche, Bernard, 'Lieux de l'insolite', *Le Devoir*, 19 September 1999, p. D10.

Lambrecht, Luk, 'Banaliteit', *Knack Weekend*, 21 February 1990, p. 11.

Lamoureux, Johanne, 'Territoire occupé: l'endroit du décor', *Trois: Revue d'Ecriture et d'Erudition*, vol. 4, no. 1 (Autumn 1988), p. 78.

Lavoie, Vincent, 'Chroniques photographiques récentes', *Portrait d'un malentendu*, Dazibao: Montréal, 1996, p. 19.

——, 'Lynne Cohen: Galerie des Archives', *Parachute*, no. 84 (October, November, December 1996), p. 56.

Leffingwell, Edward, 'Lynne Cohen at P.P.O.W.', *Art in America*, vol. 88, no. 6 (June 2000), pp. 117–118.

Lehman, Henry, 'Gallery Roundup', *Montreal Star*, 17 September 1975, p. E13.

——, 'The Image Is Fixed', *Montreal Star*, 31 July 1976, p. D3.

Littlefield, Kinney, 'Remaking the Ideal', *OC Register*, 9 May 1991, pp. 1, 8.

Littman, Sol, 'This Woman Really Knows Her "Kitsch"', *Toronto Star*, 31 December 1978, p. A14.

Loke, Margaret, 'Lynne Cohen: P.P.O.W.', *Art News*, no. 91 (May 1992), p. 128.

'Lynne Cohen, Hôtel des Arts/ Frac Limousin', *Art Press*, no. 175 (December 1992), p. 63.

'Lynne Cohen', *Connaissance des Arts*, no. 488 (October 1992), p. 140.

Marcel, Christine, 'Double mixte (Générique 2)', *Parachute*, no. 79 (July, August, September 1995), pp. 36–37.

Mark, Lisa Gabrielle, 'Under Construction: Olga Korper Gallery' *C Magazine*, no. 60 (November 1998–January 1999), p. 43.

Meyer, James, 'Lynne Cohen: P.P.O.W.', *Flash Art*, vol. 25, no. 163 (March/April 1992), p. 114.

Meuris, Jacques, 'Lynne Cohen, l'ordinaire et l'extraordinaire', *La Libre Belgique*, 16 February 1990.

Murtagh, Gina, 'Lynne Cohen', *Contact Sheet 61*, Light Work, Syracuse, 1988.

Naphégyi, Caroline, 'Lynne Cohen', *Le Journal des Expositions*, no. 32 (January 1996), p. 2.

Nielson, M., *108-Review*, May/June, 1988, pp. 3–4.

Nuridsany, Michel, 'Suite, série, séquence', *Le Figaro*, 7 October 1981, p. 27.

O.H., 'Photo', *L'Express*, no. 1424, 28 October 1978, p. 13.

Ollier, Brigitte, 'Lynne Cohen, derrière le rideau', *Libération*, 21 October 1992.

——, 'Lynne Cohen', *Libération*, 19 January 1996, p. 37.

Pejic, Bojana, 'Ex-Abstentia', *Artforum*, vol. 28, no. 8 (April 1990), p. 144.

Poitevin, Jean-Louis, 'Silences', *Clichés*, no. 61 (December 1990), pp. 48–53.

Pomparat, Catherine, 'A l'Infinitif pluriel', *CV Photo*, no. 37 (Winter 1996), p. 7.

Pontbriand, Chantal, 'Notes sur l'avenir de la photographie canadienne contemporaine', *Parachute*, no. 42 (March, April, May 1986), p. 4.

Popelier, Bert, 'Zonderlige Werkelijkheid', *Aartsenkrant*, 6 March 1990.

Raczka, Tony, 'Things, Exactly As They Are. Typologies: Nine Contemporary Photographers at the Newport Harbor Art Museum', *Artweek*, vol. 22, 9 May 1991, p. 10.

Renggli, Hans, 'Die Kunstlichkeit unserer Lebensraume', *Tages Anzeiger*, 16 February 1989.

Roegiers, Patrick, 'Territoires occupés', *Le Monde*, September 1988, p. 14.

——, 'Territoire occupé', *L'Oeil Multiple*, Paris: Editions La Manufacture, 1988, p. 431.

Scheman, Naomi, 'Photography and the Politics of Vision,' *Engenderings*, London, New York: Routledge, 1993, p. 160.

Smith, Roberta, 'The World through Women's Lenses', *New York Times*, 13 December 1996, p. C28.

Taylor, Kate, 'Cold Images in Warm Frames Prove Powerfully Disquieting', *Globe and Mail*, 20 March 1992, p. C9.

——, 'Incriminating Evidence: Photographs by Lynne Cohen', *Globe and Mail*, 23 June 1994, p. C4.

Taylor, Kendra, 'Lynne Cohen: P.P.O.W.', *Art News*, vol. 87, no. 8 (October 1988), p. 177.

Taylor, Sue, 'Lynne Cohen at PrintworksLtd', *Art in America*, vol. 78, no. 9 (September 1990), pp. 203–204.

Thomas, Ann, 'Lynne Cohen', *Le Mois de la photo à Montréal*, Montréal, Vox Populi, 1989, p. 170.

Toupin, Gilles, 'Une Photographie en train de s'affirmer', *La Presse*, 31 July 1976, p. C15.

Tousley, Nancy, 'Photographer Gets behind the Scenes of Everyday Life', *Calgary Herald*, 11 June 1992, p. C6.

——, 'Banff Purchase', *Vanguard*, vol. 8, no. 8 (October 1979), p. 27.

Trebay, Guy, 'Lynne Cohen', *Village Voice*, 24 June 1986.

Turine, Roger-Pierre, 'Dites-le avec des photos', *Le Vif/ L'Express*, 9 March 1990, p. 112.

Vacherot, J.-P., 'Lynne Cohen photographie la Nièvre', *Centre-France*, 9 June 1991.

Warner, Marina, 'Breaking the Photographic Mould', *New Statesman and Society*, 17 March 1989.

Weinstein, Matthew, 'Lynne Cohen: P.P.O.W.', *Artforum*, vol. 27, no. 2 (October 1988), p. 149.

White, Peter, 'Wall-to-wall Photo Show', *Globe and Mail*, 28 January 1977, p. 14.

Winsten, Archer, 'Whitney's American Moods', *New York Post*, 15 February 1974, p. 52.

Wise, Kelly, 'Cohen's Unmasked Interiors: Surreal, Sophisticated', *Boston Globe*, 21 May 1992, p. 87.

Zimmer, William, 'A Quietness Pervades: Surreal Works by Three Photographers', *New York Times*, Friday 26 February 1989, p. 22.

ACKNOWLEDGMENTS

I am indebted to those responsible for the laboratories, spas, military installations, halls and men's clubs that appear in my photographs. Without their kindness and cooperation, there would have been no pictures.

The following people have helped me in the production and exhibition of my work in ways I very much appreciate: Danielle Allard, Pool Andries, Catherine Arthus-Bertrand, Pep Benloch, Susan Bernard, Lisa Binnie, Mark Blichert, Sidney and Hanna Block, Andrea Blum, James Borcoman, Ed Burtynsky, David Byrne, Scott Cato, Louise Chénier, Claire Christie, Jean-Pierre Criqui, Cherise Crockett, Pierre Dalpé, Bert Danckaert, Christine Davis, Alvaro de los Angeles, Christophe Durand-Ruel, Nicolás Sánchez Durás, Shawna Eberle, Dan Ebert, Guadalupe Echevarria, Nuria Enguita, Michael Flomen, Marc Freidus, Karin Hanssen, Robert Hiebert, Jeffrey Hoone, Rodolphe Janssen, Sebastién Janssen, Olga Korper, Johanne Lamoureux, Vincent Lavoie, Fabienne LeClerc, Francine Lemieux, John McElhone, Tessa McWatt, Alberto Martín, Jason Murison, Wendy Olsoff, Frédéric Paul, Lori Pauli, Stefan Petrik, Penny Pilkington, Catherine Pomparat, Gregory Salzman, Hans Scholten, Brydon Smith, Louise Spence, Vincent Tangredi, Nick Welch, Loretta Yarlow and Christina Zelich.

Also I should like to acknowledge the encouragement and support I have received from P.P.O.W., New York; Galerie Rodolphe Janssen, Brussels; Olga Korper Gallery, Toronto; Galería Visor, Valencia; Galería dels Angels, Barcelona; Galerie Wilma Tolksdorf, Frankfurt; Printworks, Chicago; Howard Yezersky Gallery, Boston and The Canada Council.

And thanks to Ann Thomas and William A. Ewing for believing in my work from the beginning, and to Andrew Lugg, without whom it would not have been possible.

Lynne Cohen

I am grateful to the following people who have in various ways supported the mounting of the exhibition and the production of the accompanying book. Within my own institution I owe thanks to Pierre Théberge, Director; Daniel Amadei, Director of Exhibitions and Installations; Danielle Allard, Project Manager; Mark Blickert, Designer; Louise Chénier, Secretary of the Department of Photographs; Vincent Lavoie, Assistant Curator; John McElhone, Conservator of Photographs; Steven McNeil, Inter-library loans librarian; Sat Palta, Framer; Lori Pauli, Assistant Curator; Serge Thériault, Head of Publications. The enthusiastic support of William A. Ewing, Director of the Musée de l'Élysée, was crucial to the success of this project. I also thank Susan Bernard, practicum M.A. student from Carleton University, for her initial organization of the bibliography.

The exhibition could not have been realized without the support of the lenders, Wendy Olsoff and Penny Pilkington of P.P.O.W., New York, and their staff; Todd Watts of Motel Fine Arts, New York; Michael Bell, Director, Carleton University, Ottawa, Canada; Rodolphe Janssen of Galerie Rodolphe Janssen, Brussels; Michael Flomen, Montreal; Olga Korper, Olga Korper Gallery, Toronto, and her staff; Fabienne Leclerc, Paris. Mary Stauss was a wonderful resource on the culture of mid-twentieth-century Racine, Lynne Cohen's hometown. Brydon Smith, my spouse and former colleague, and Andrew Lugg are to be thanked for reading my manuscript. As always I owe a debt of gratitude to the rest of my family and friends for their forbearance, especially to Rebekah. Above all it has been a privilege to work with Lynne Cohen, who has shown complete dedication to this project at every stage.

Ann Thomas
Curator of Photographs

INDEX